CYCLES

ILKKA UIMONEN

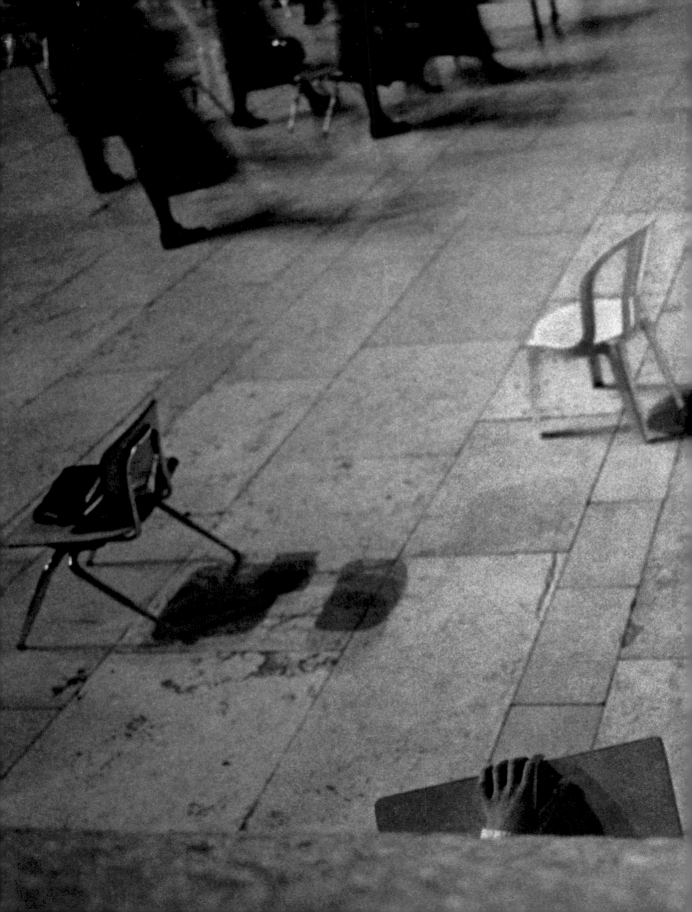

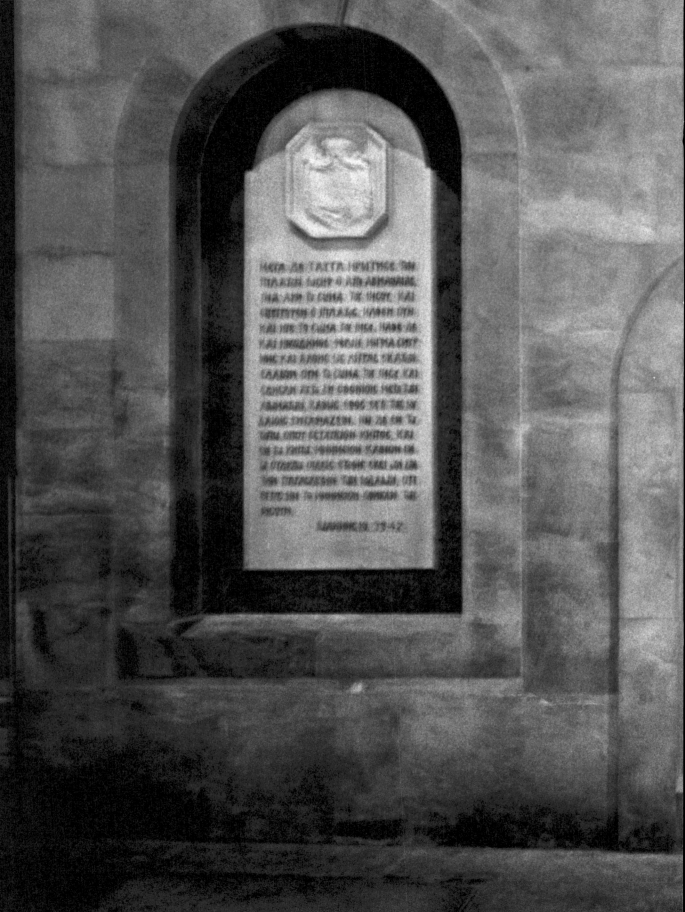

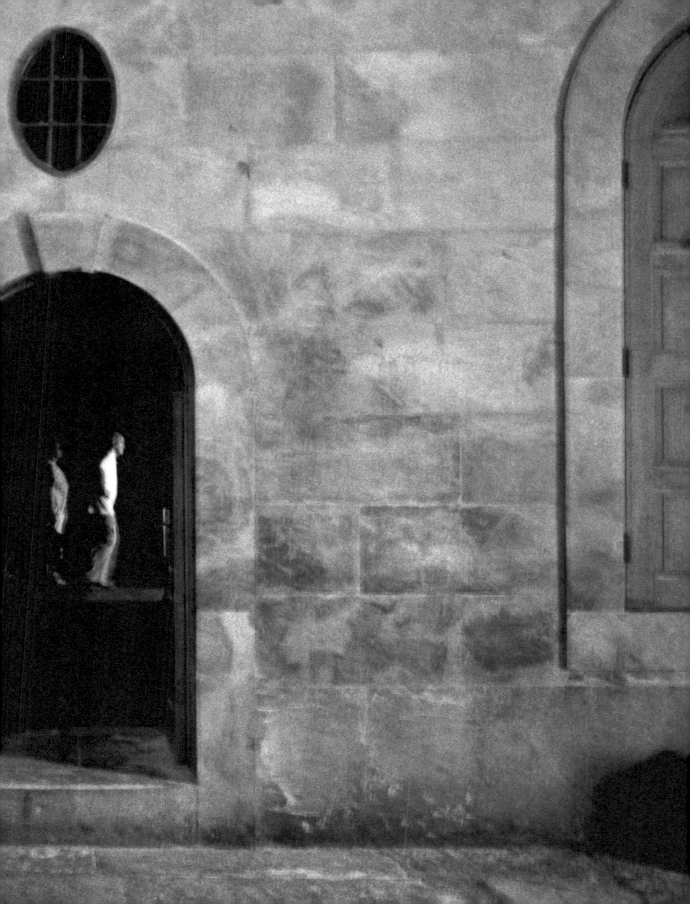

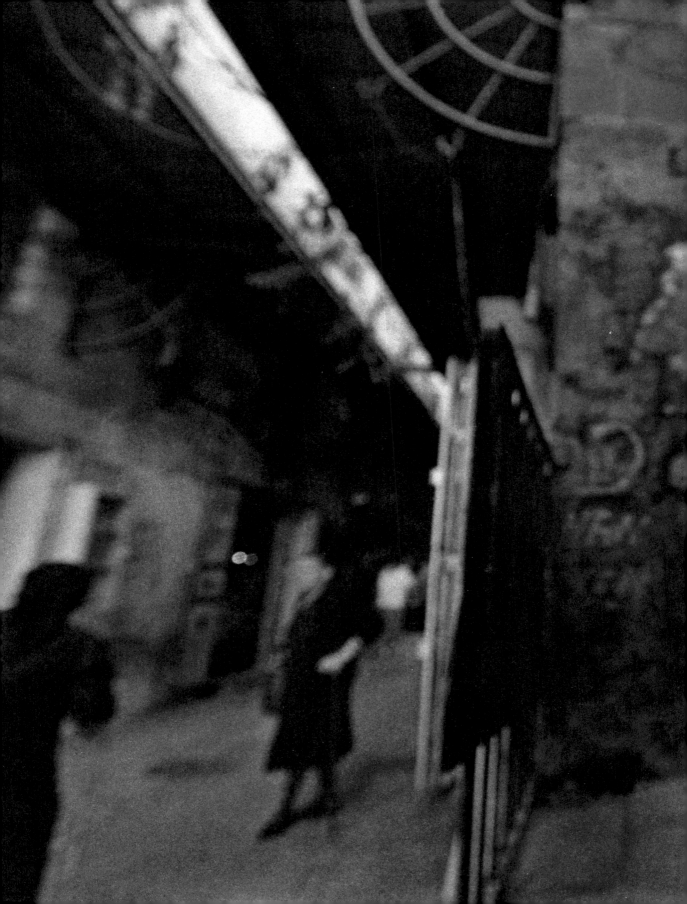

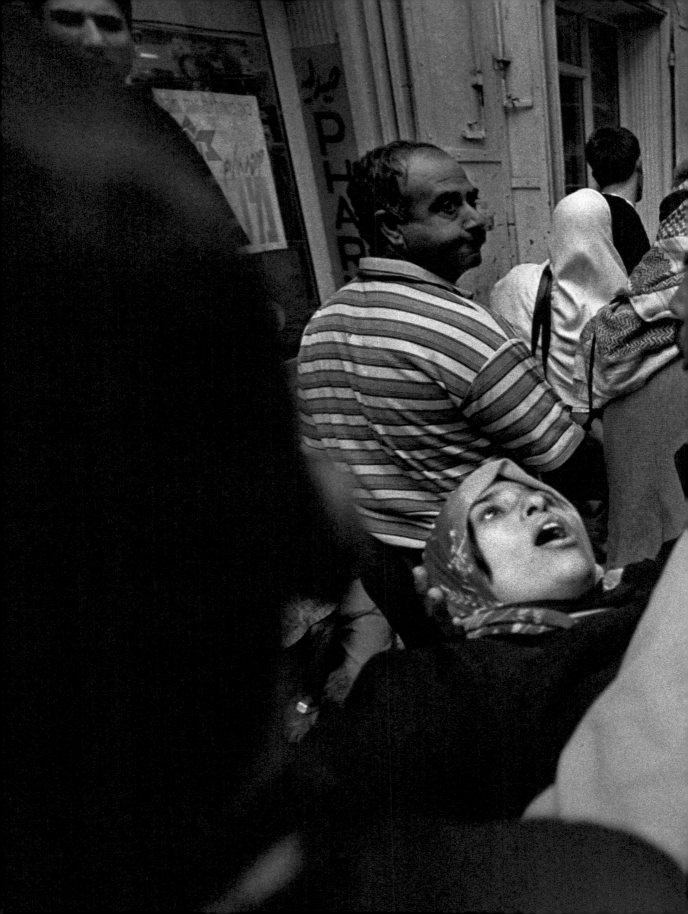

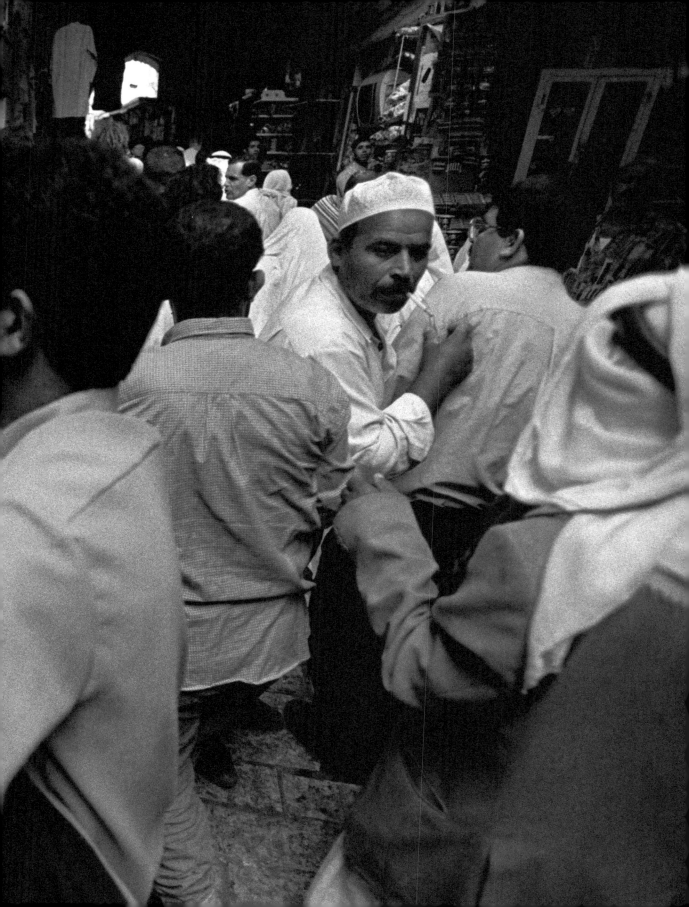

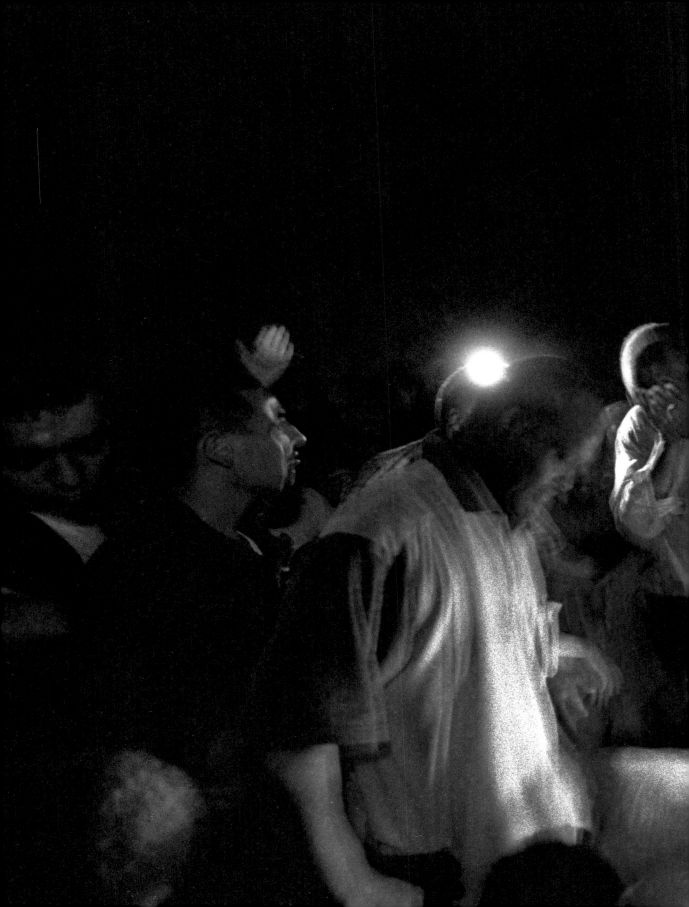

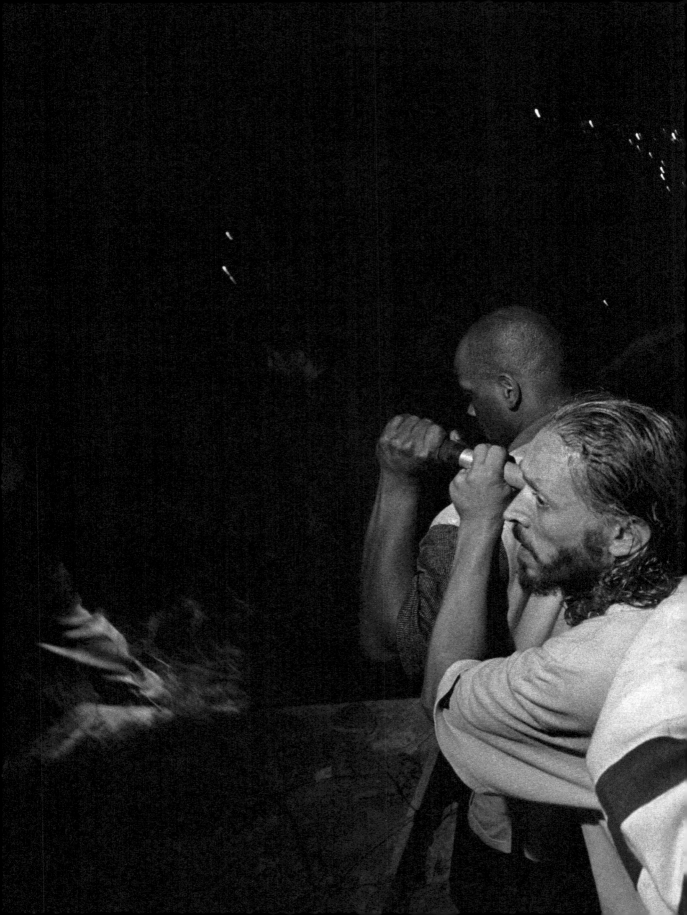

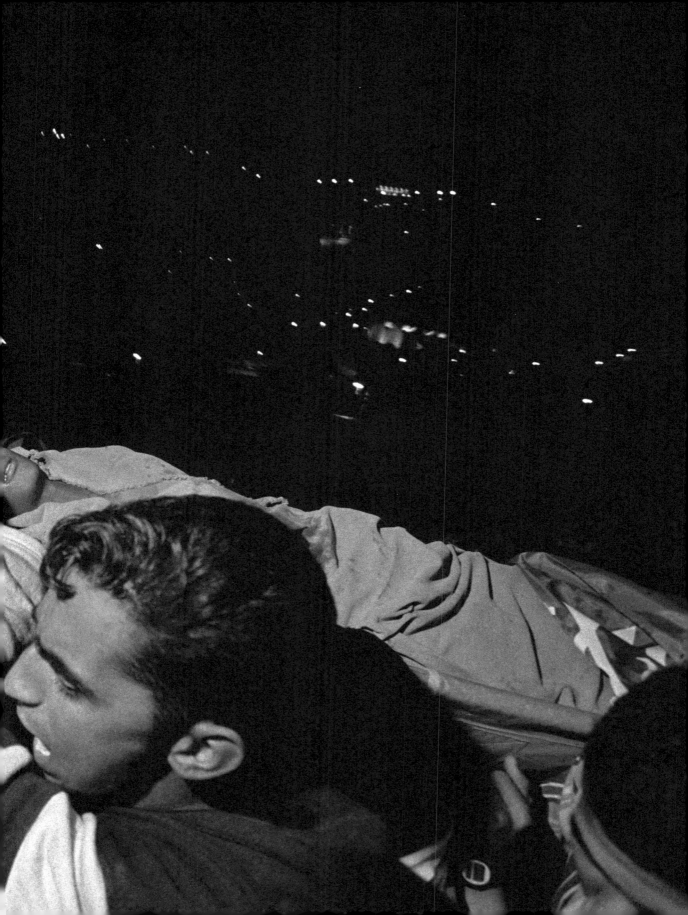

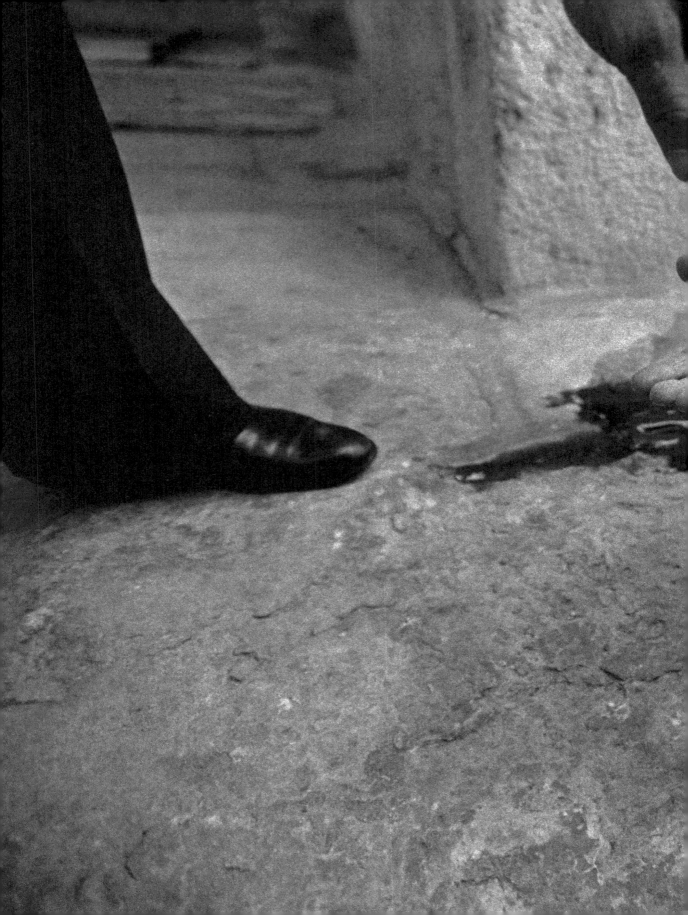

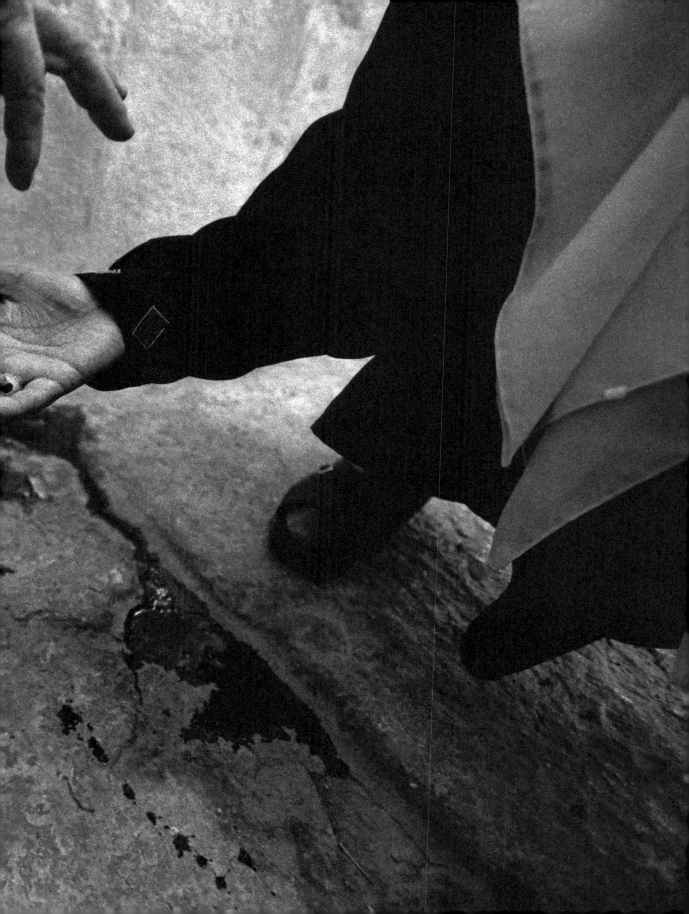

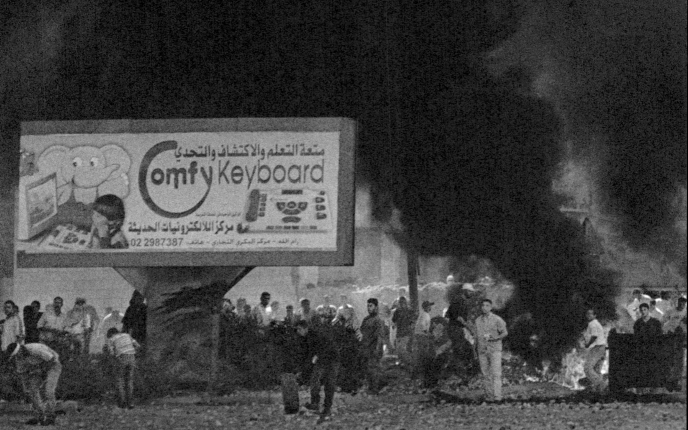

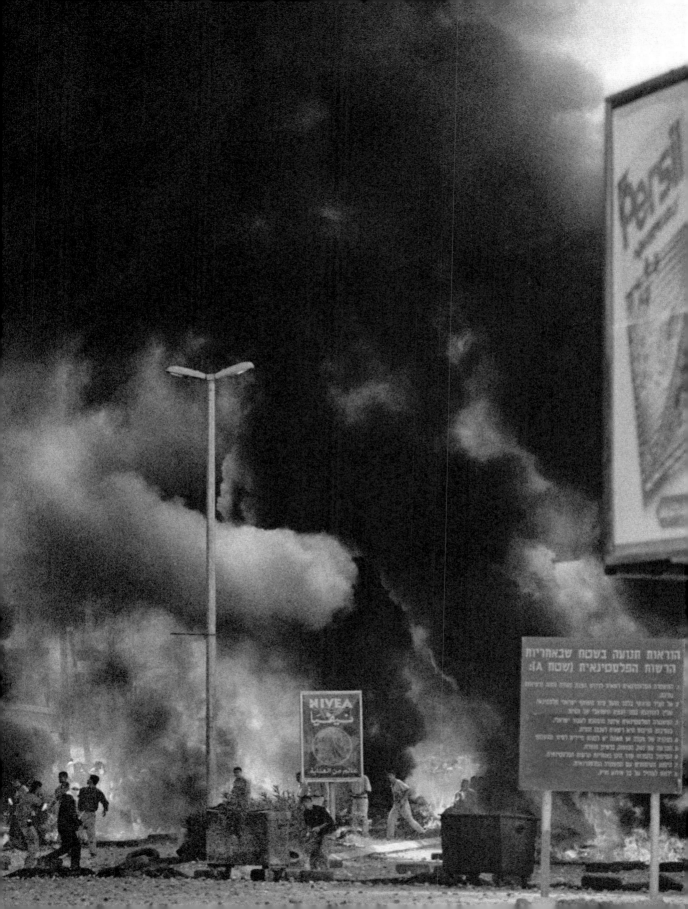

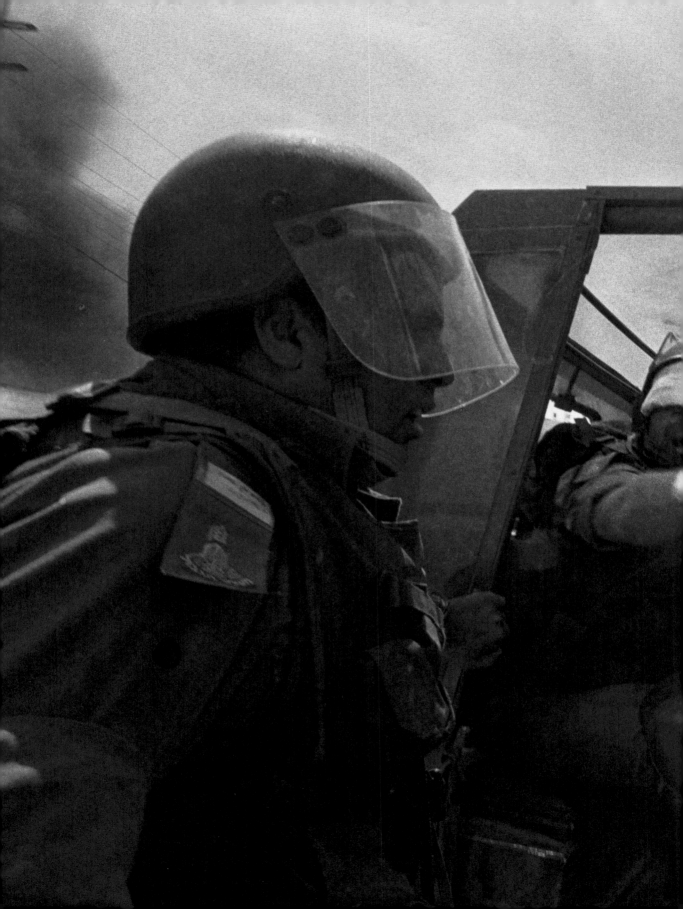

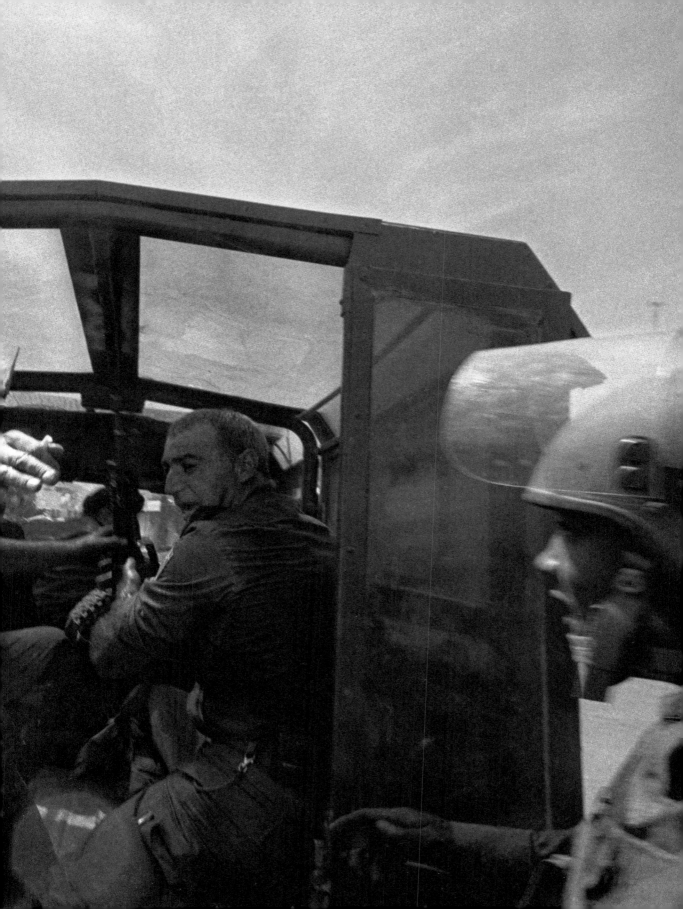

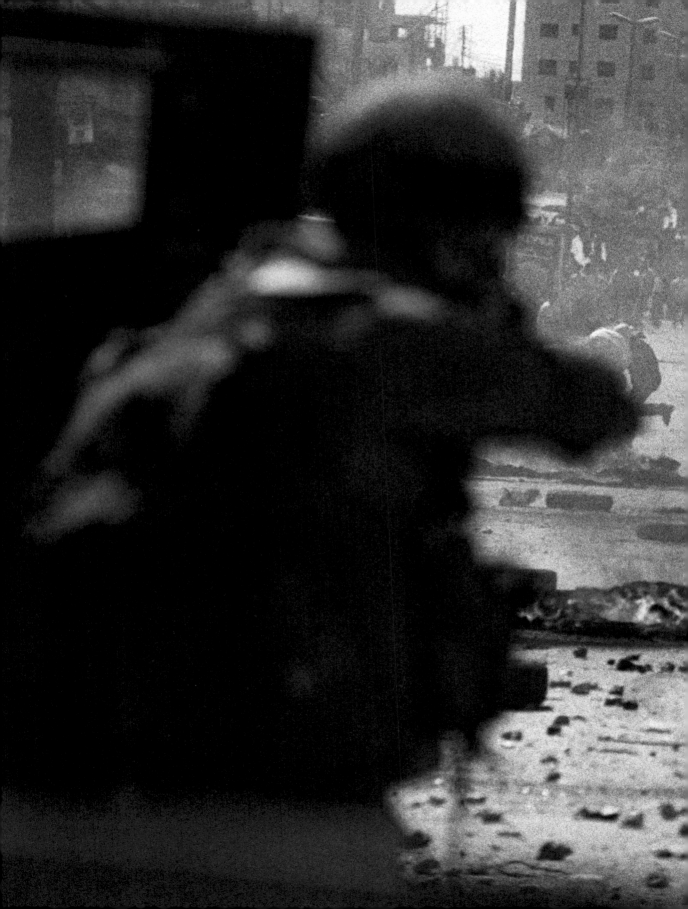

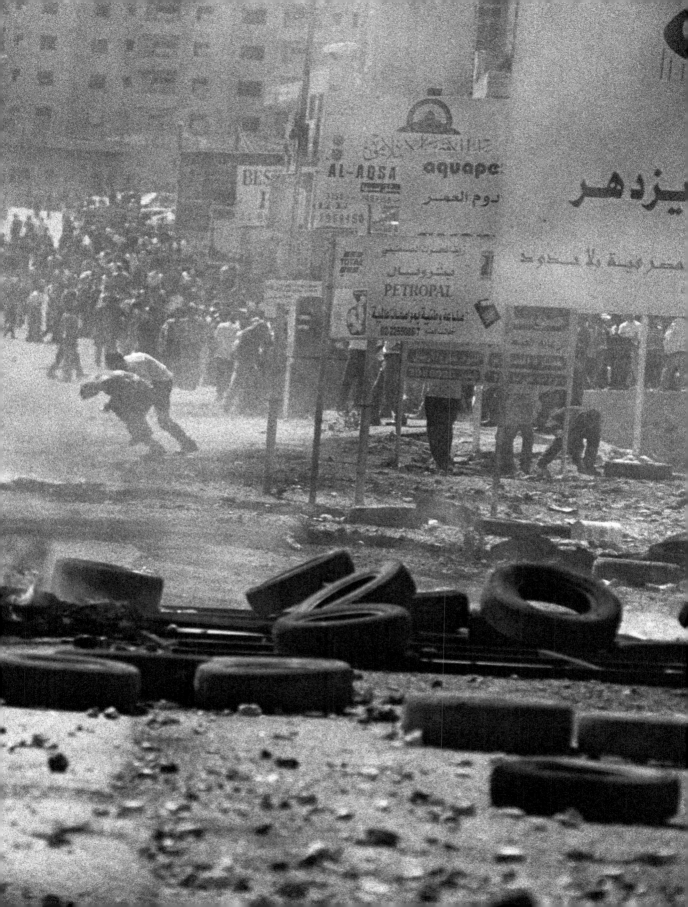

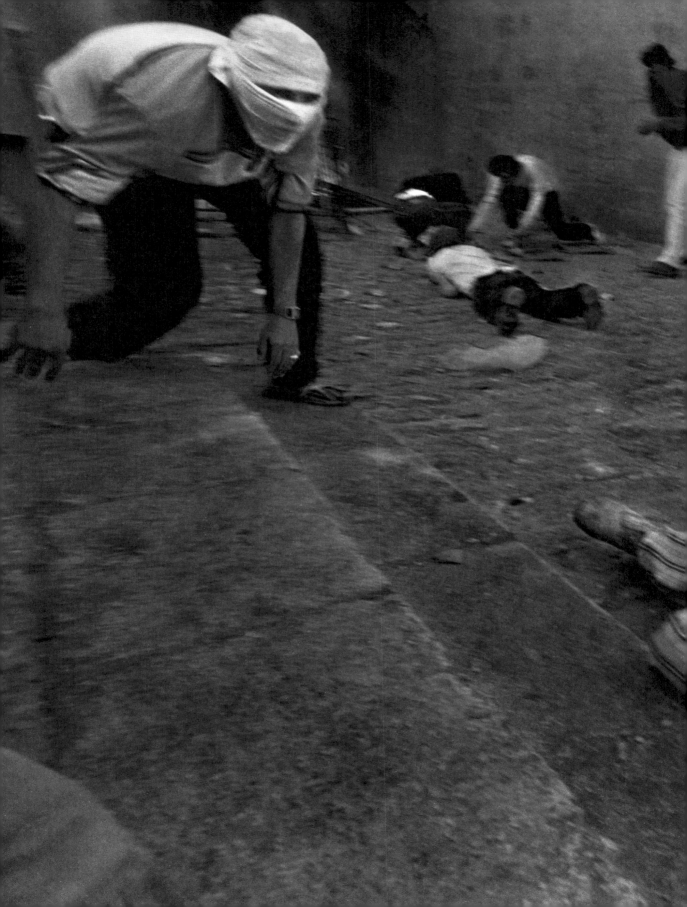

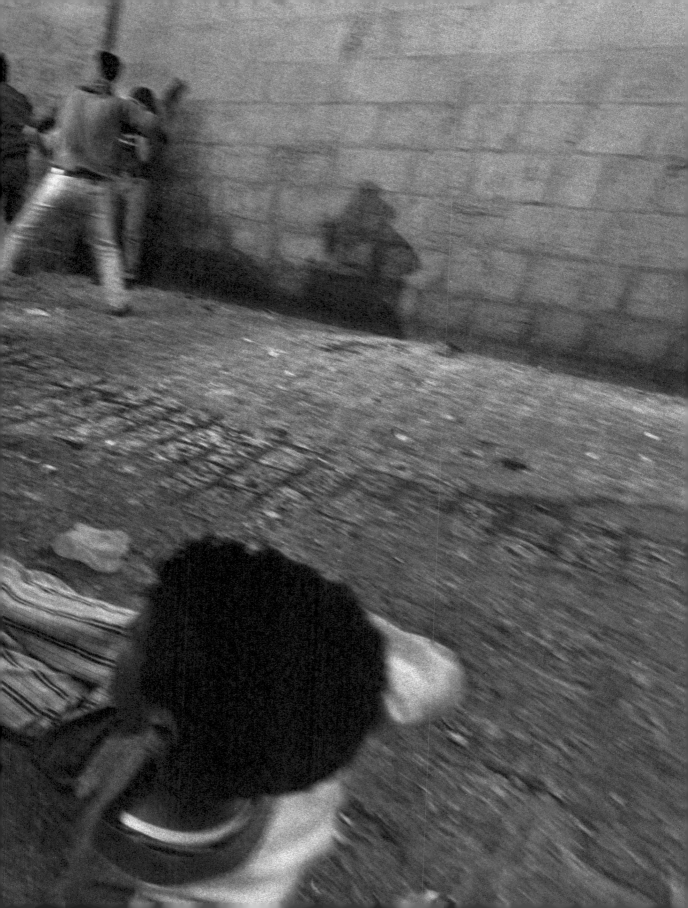

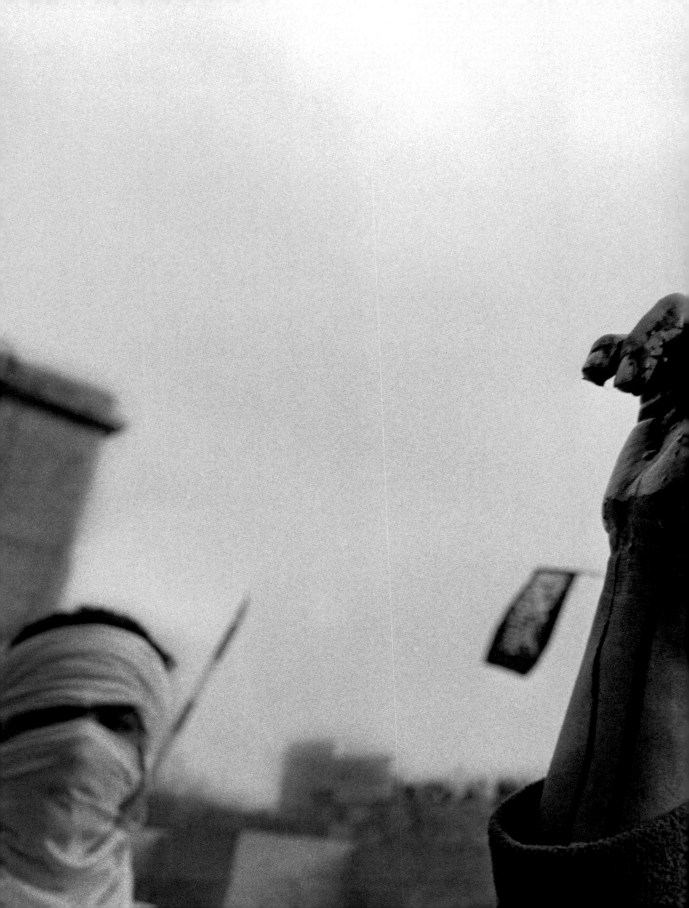

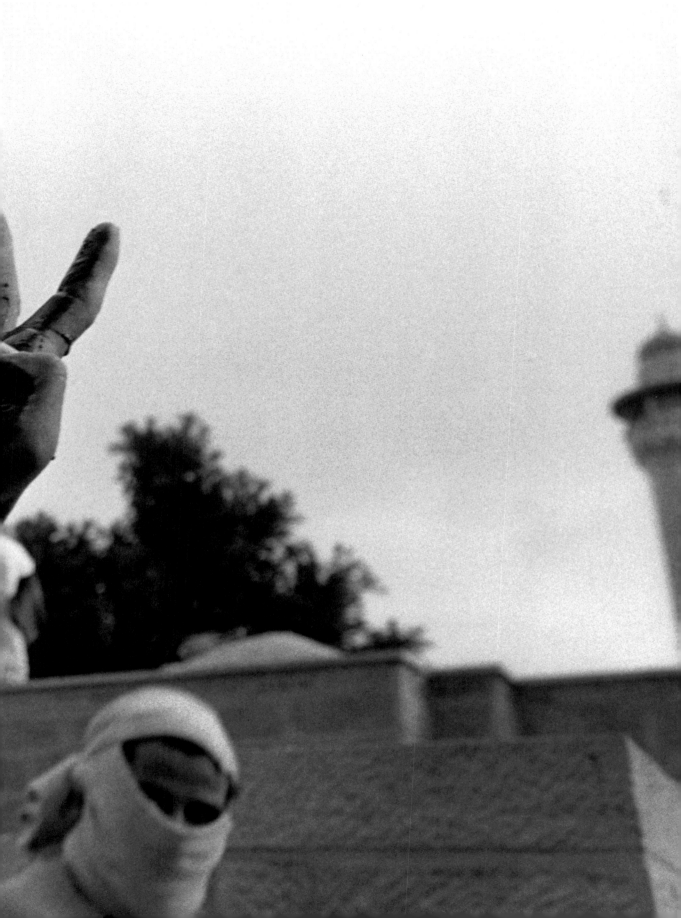

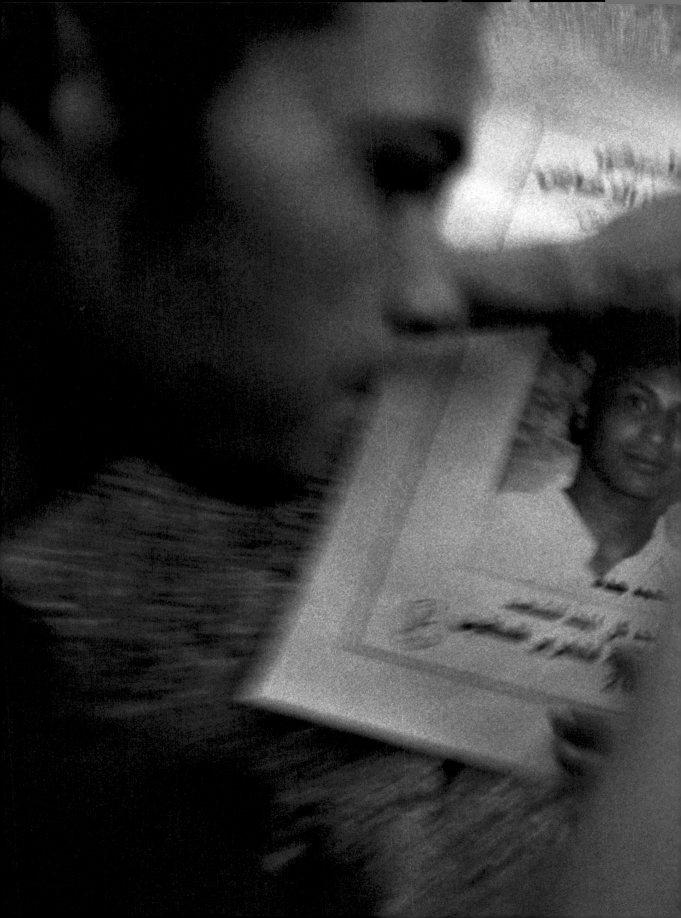

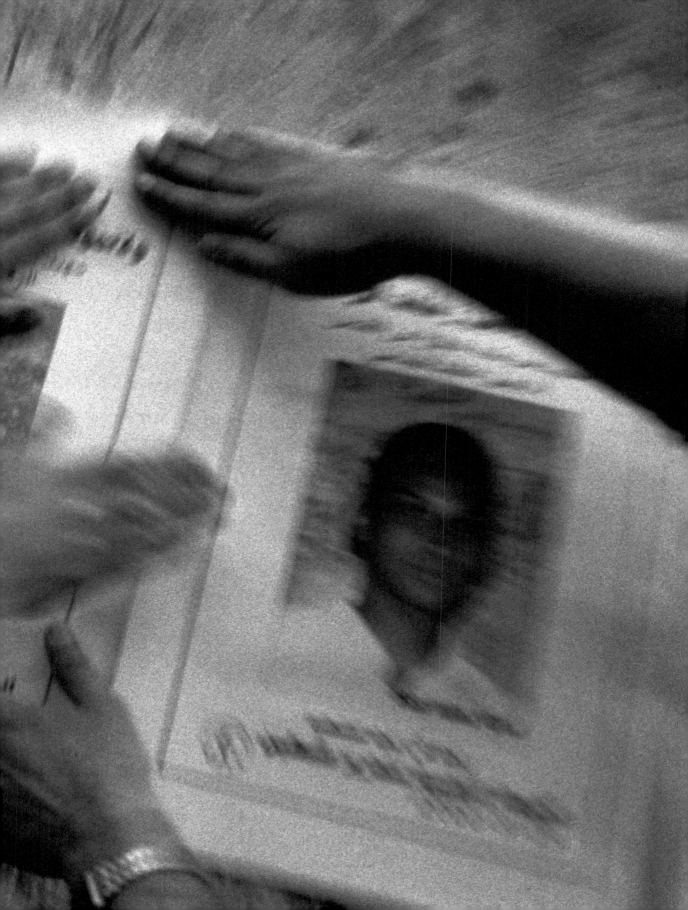

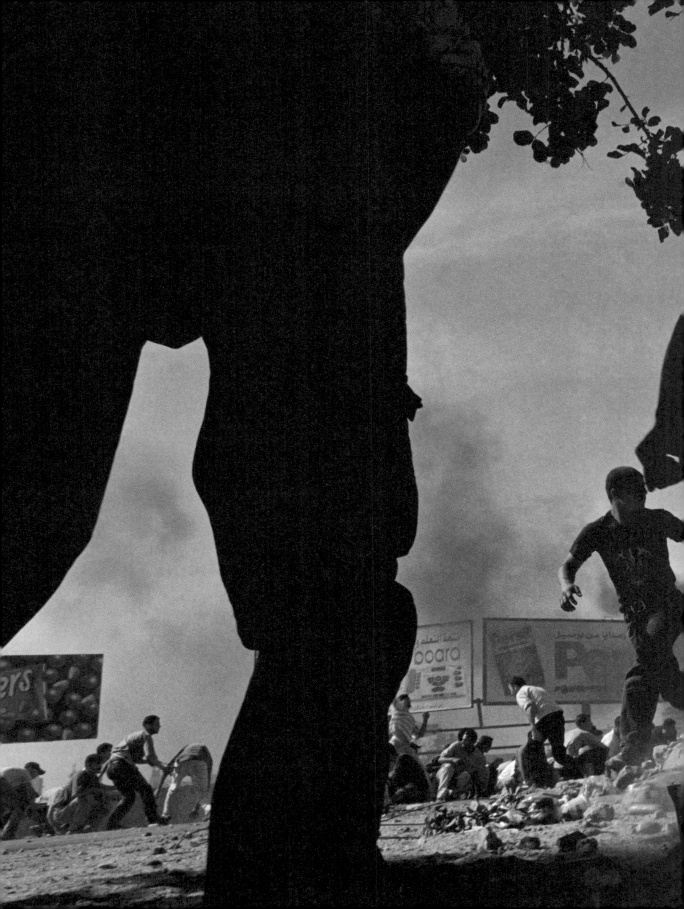

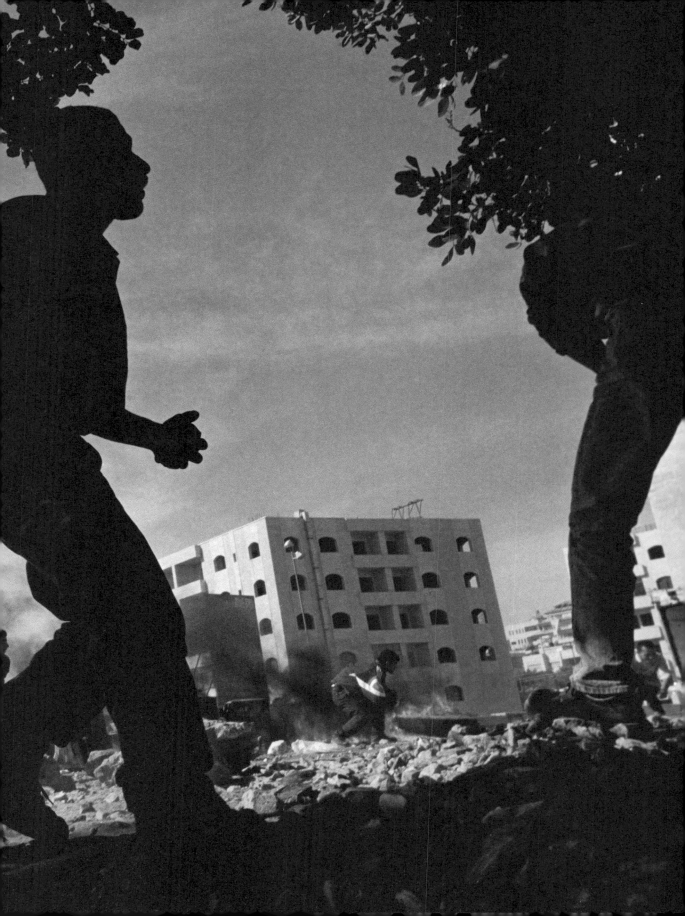

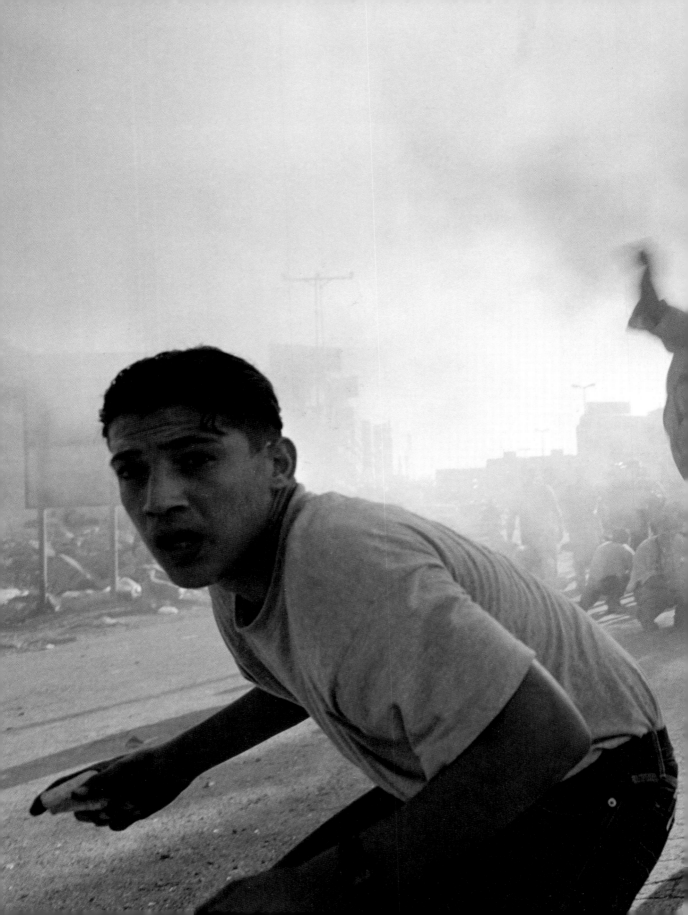

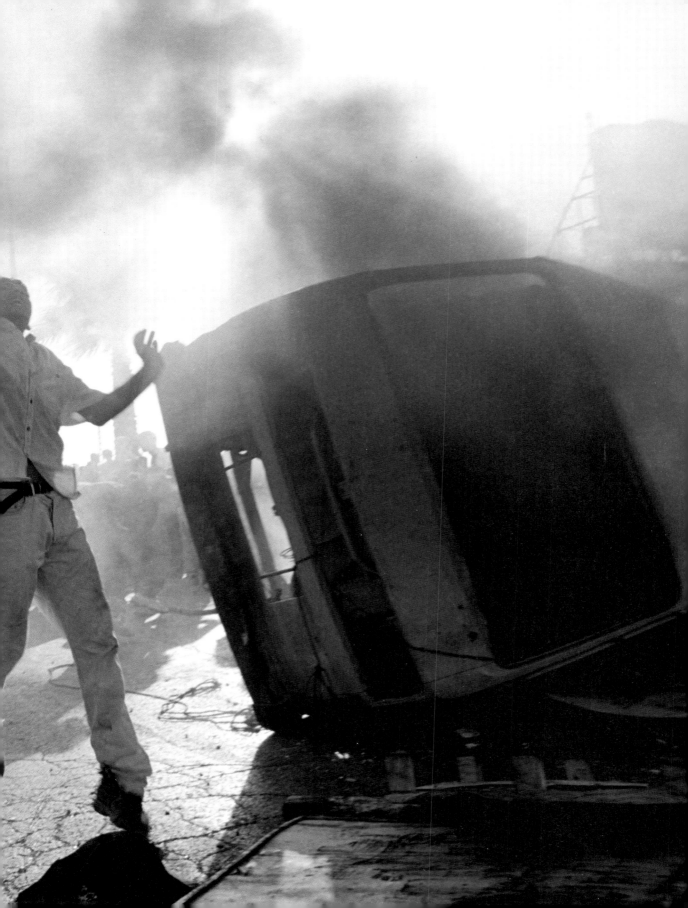

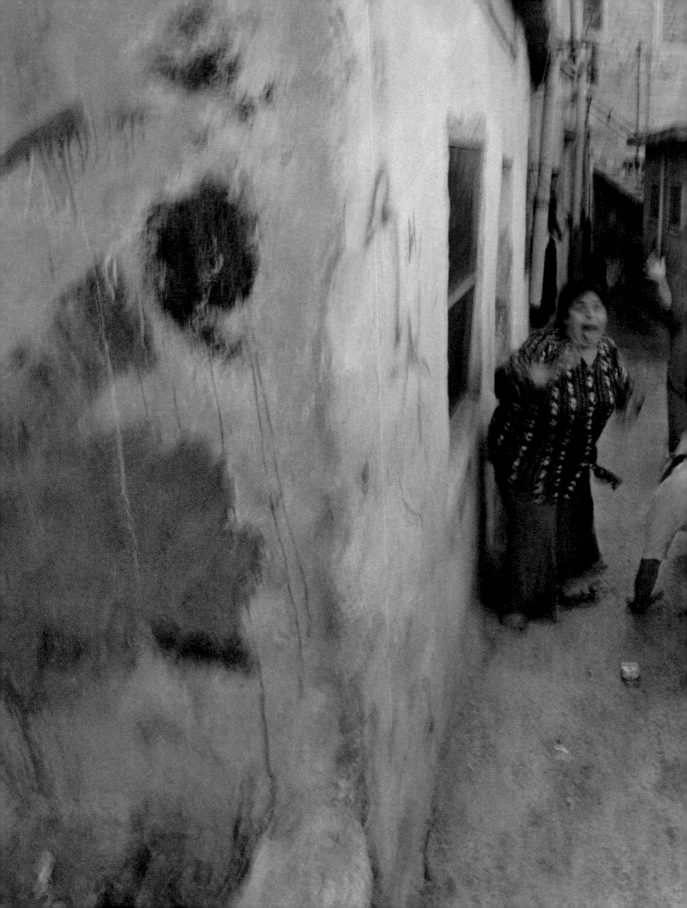

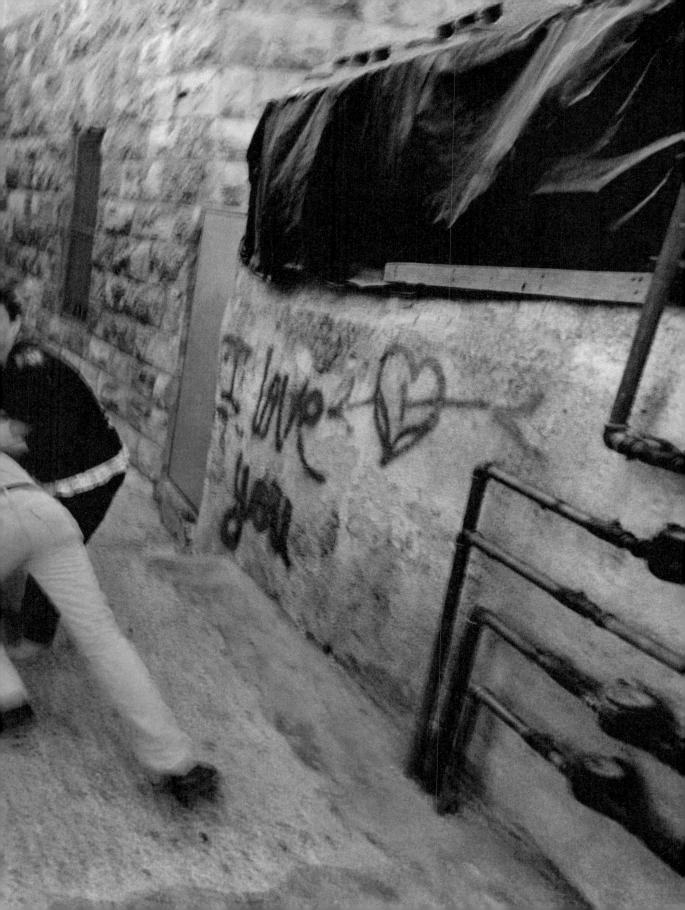

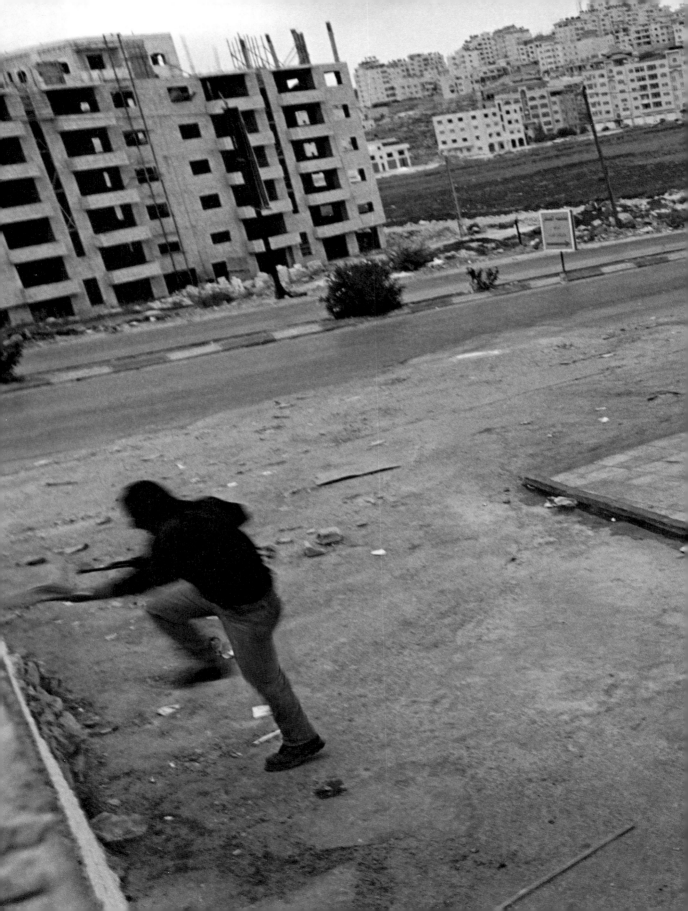

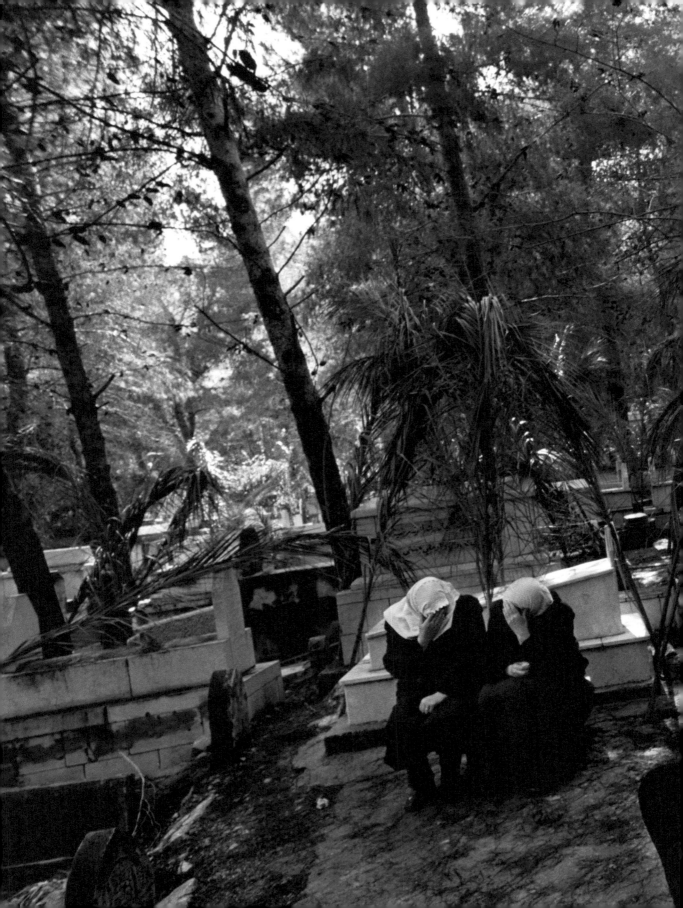

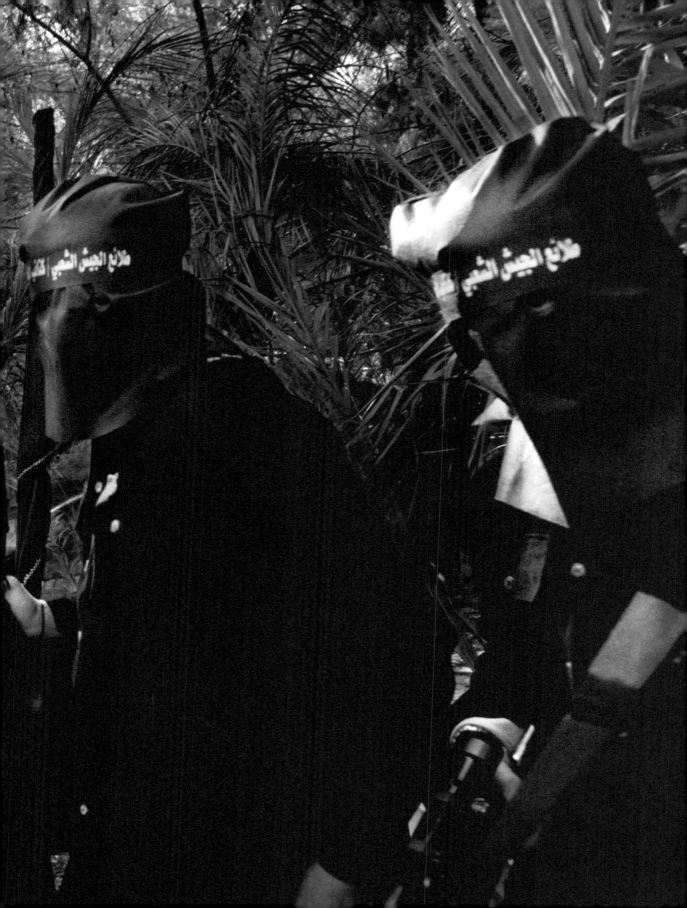

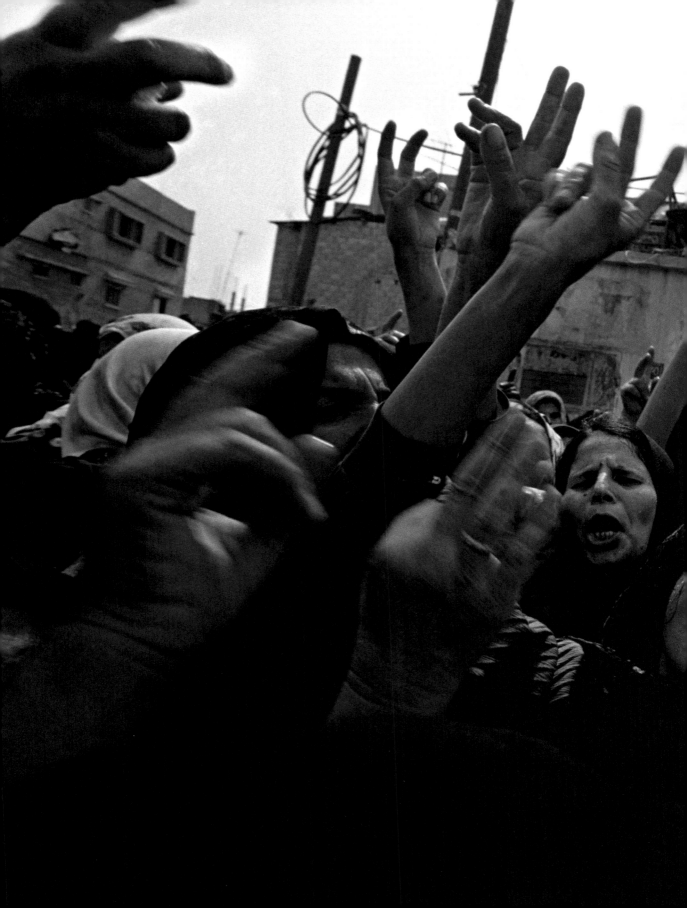

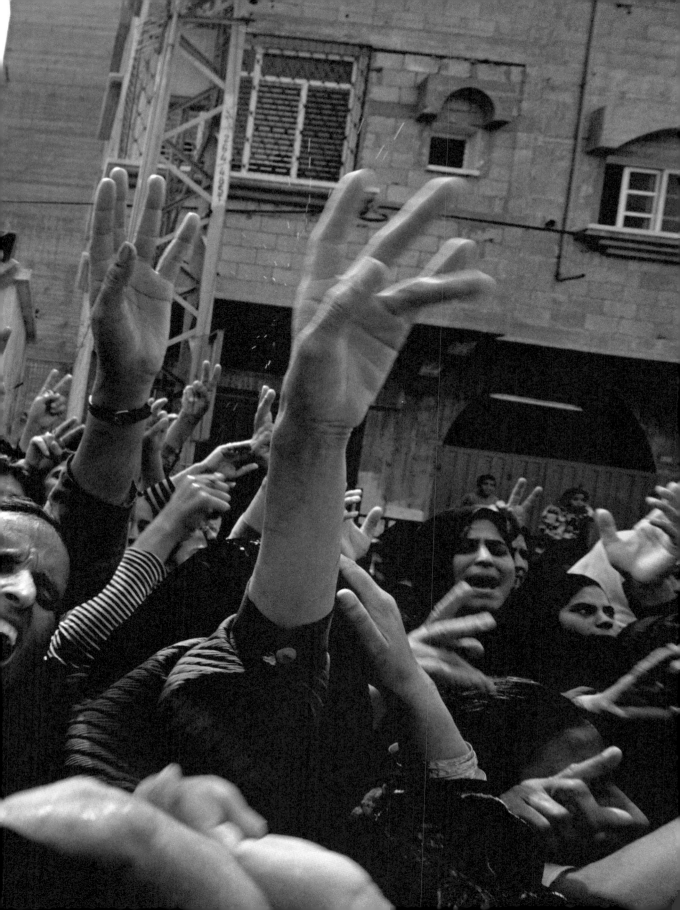

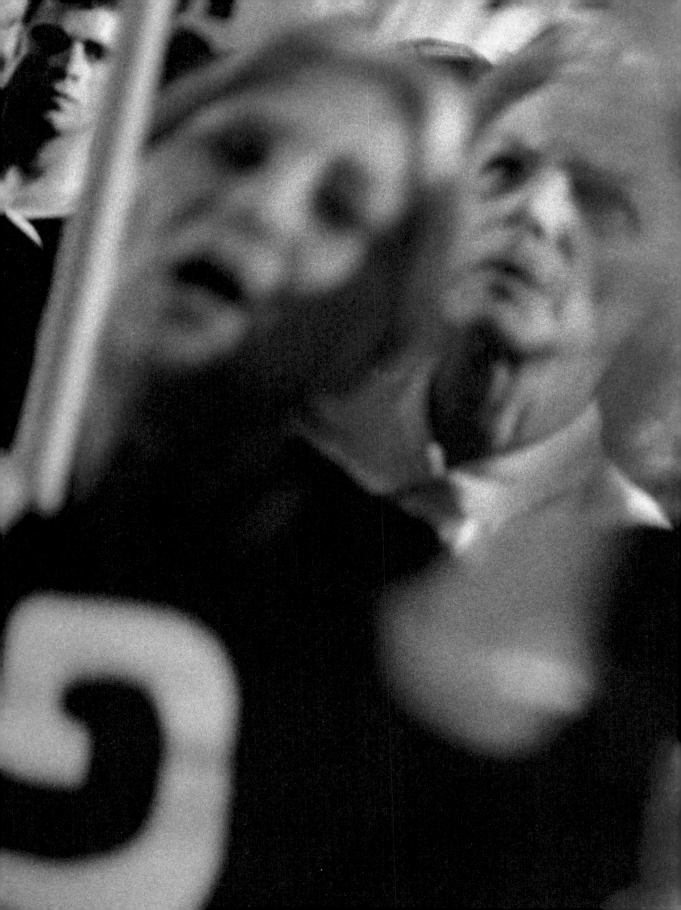

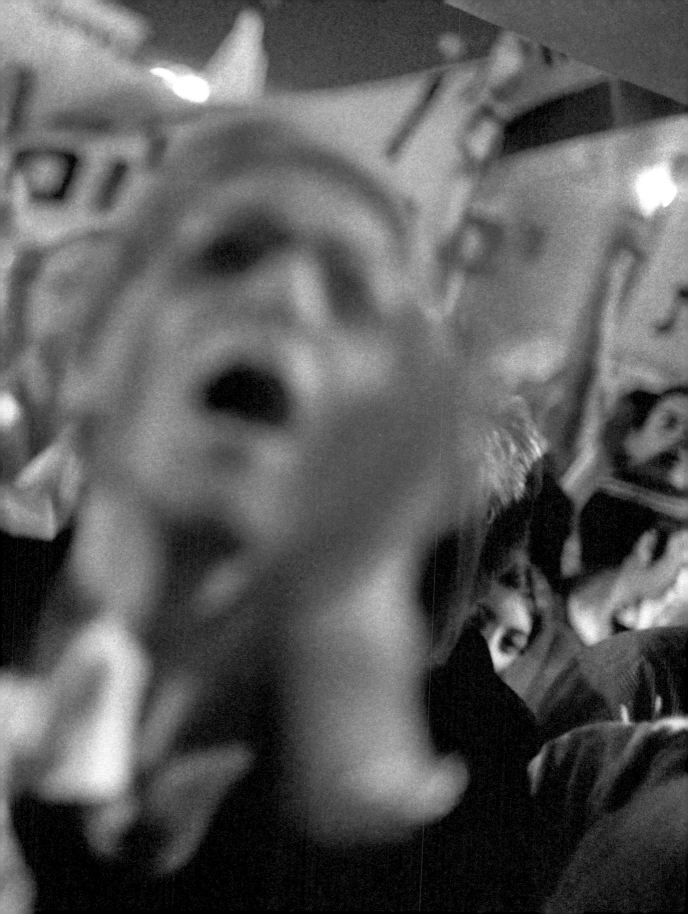

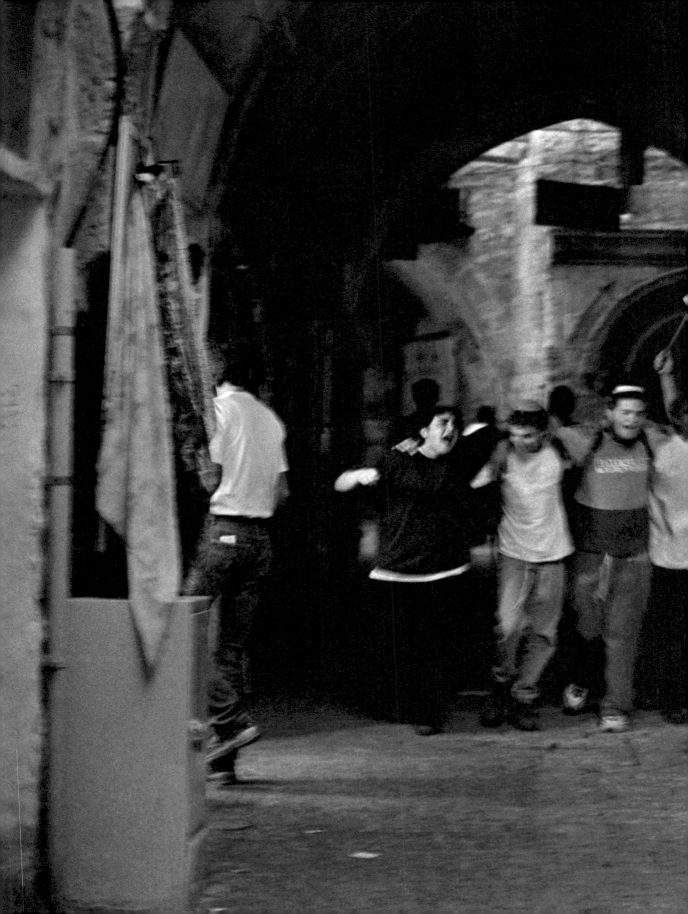

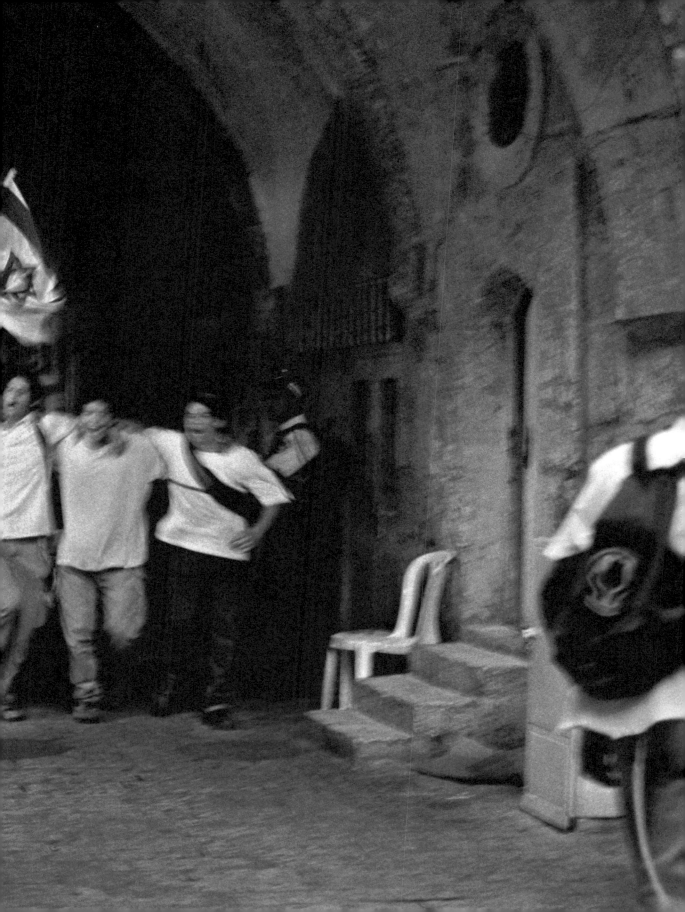

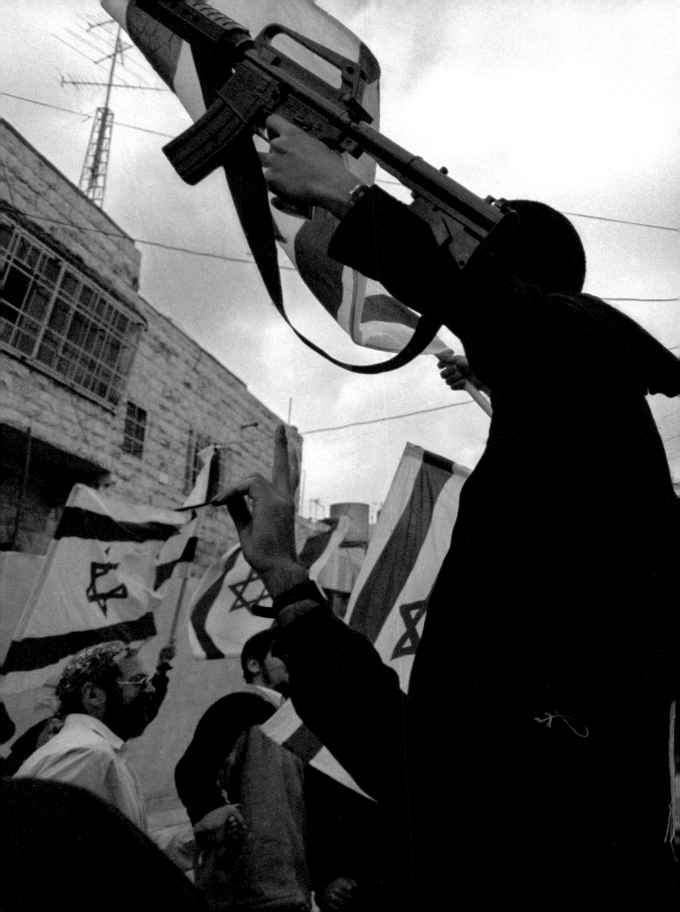

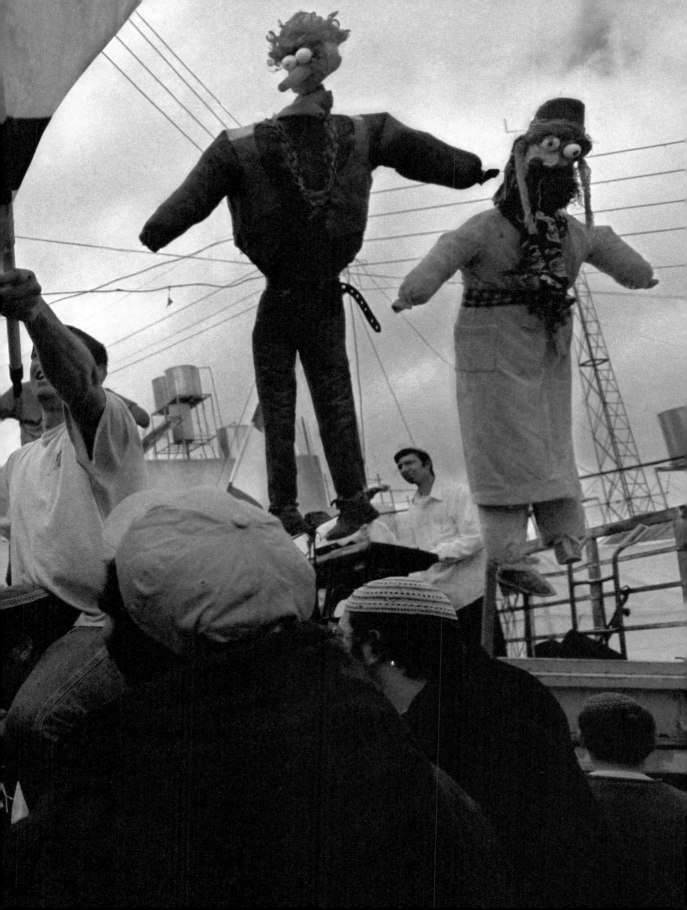

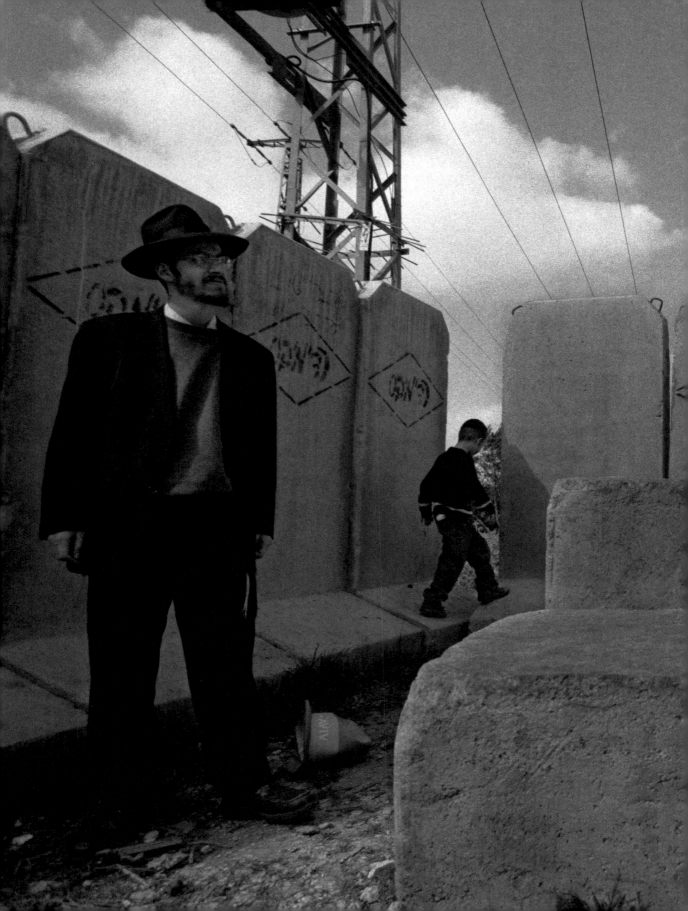

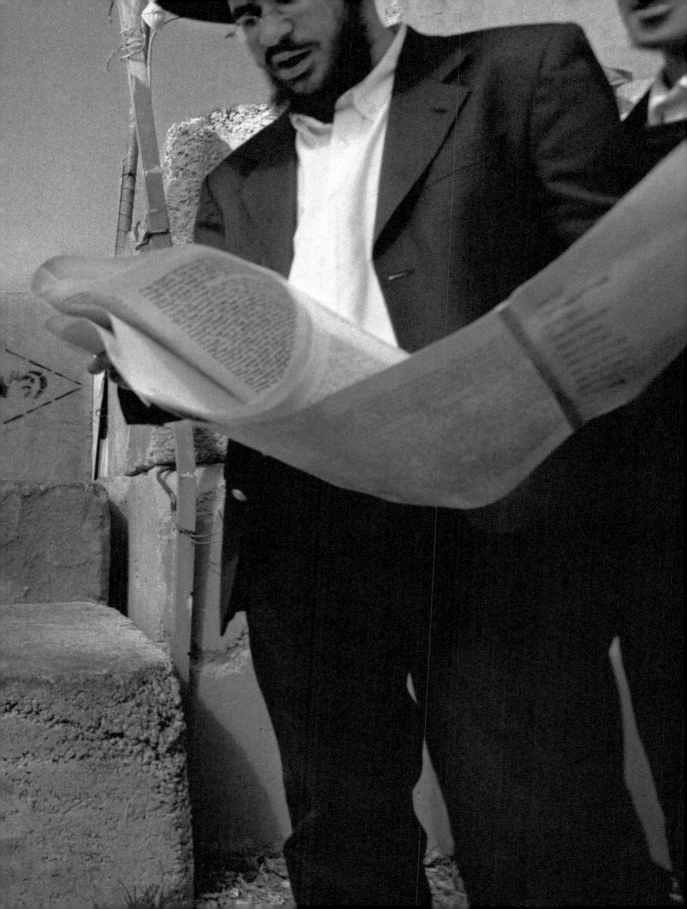

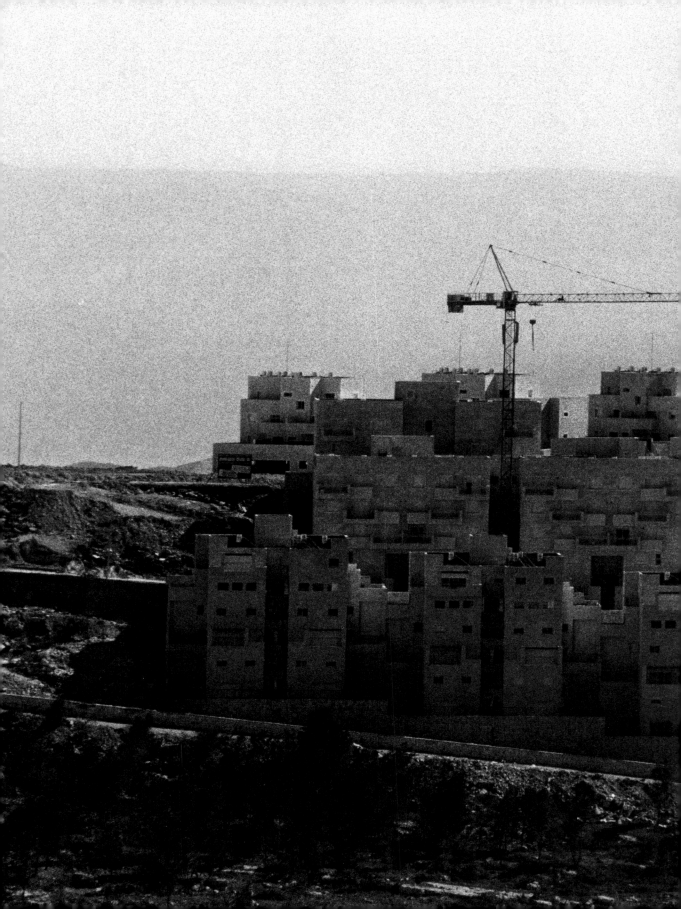

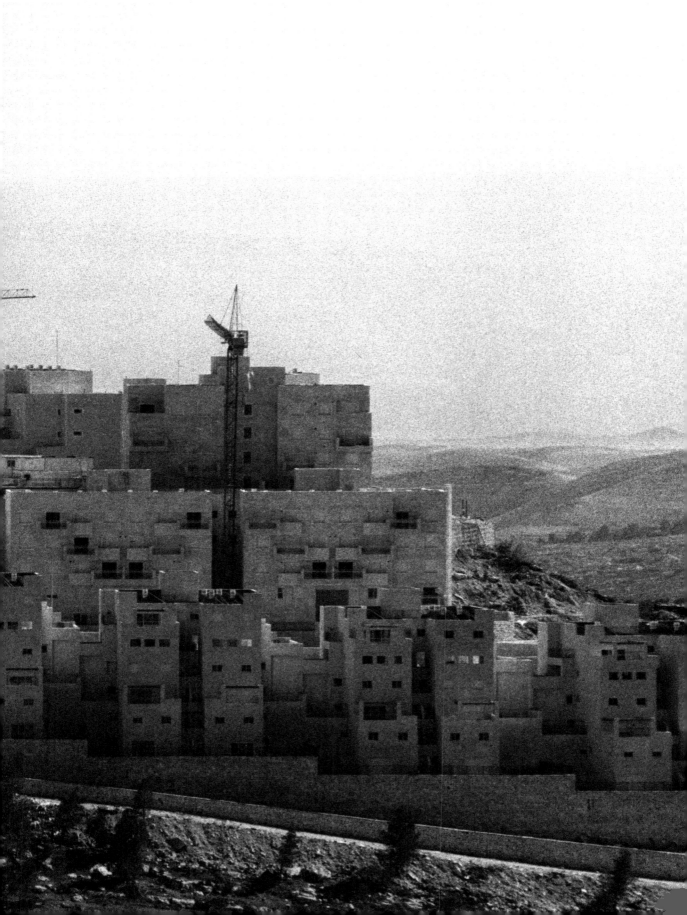

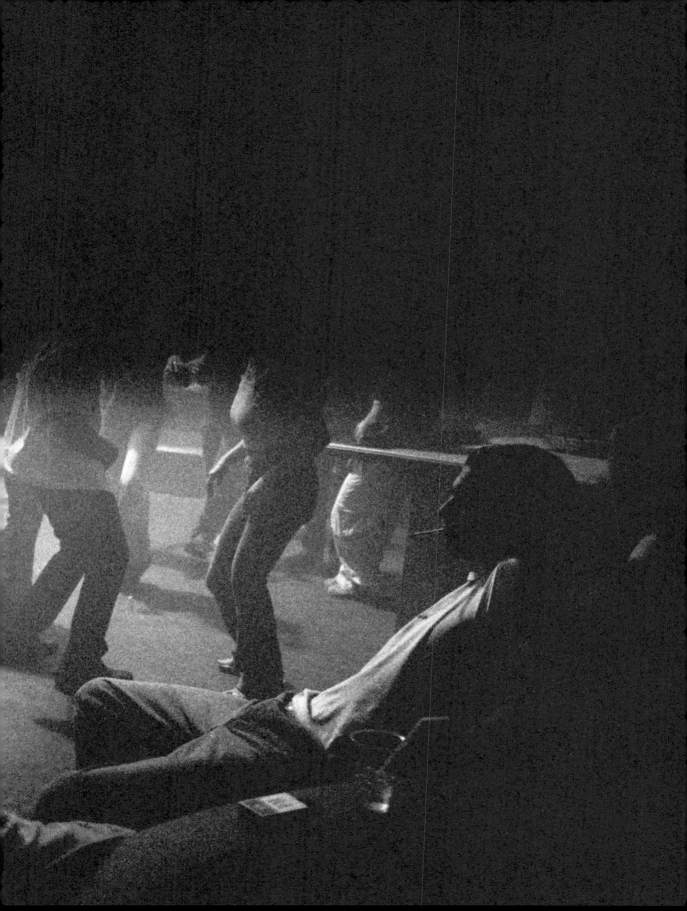

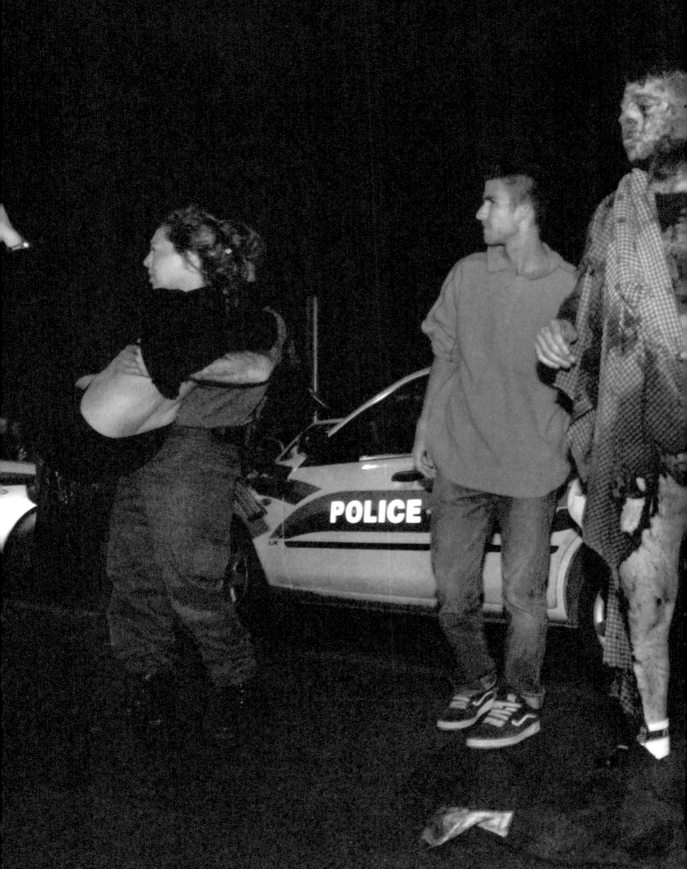

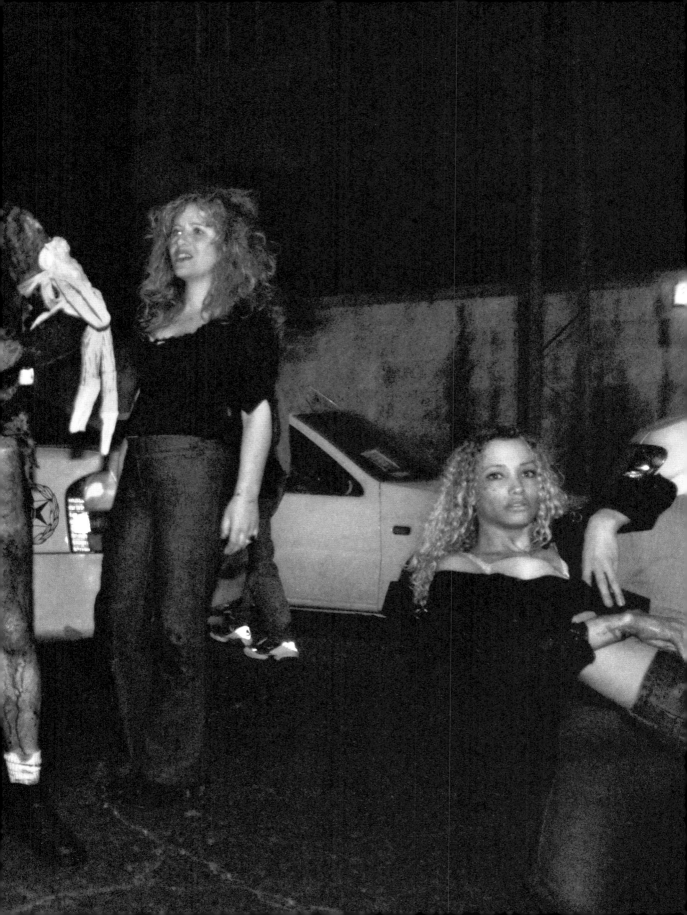

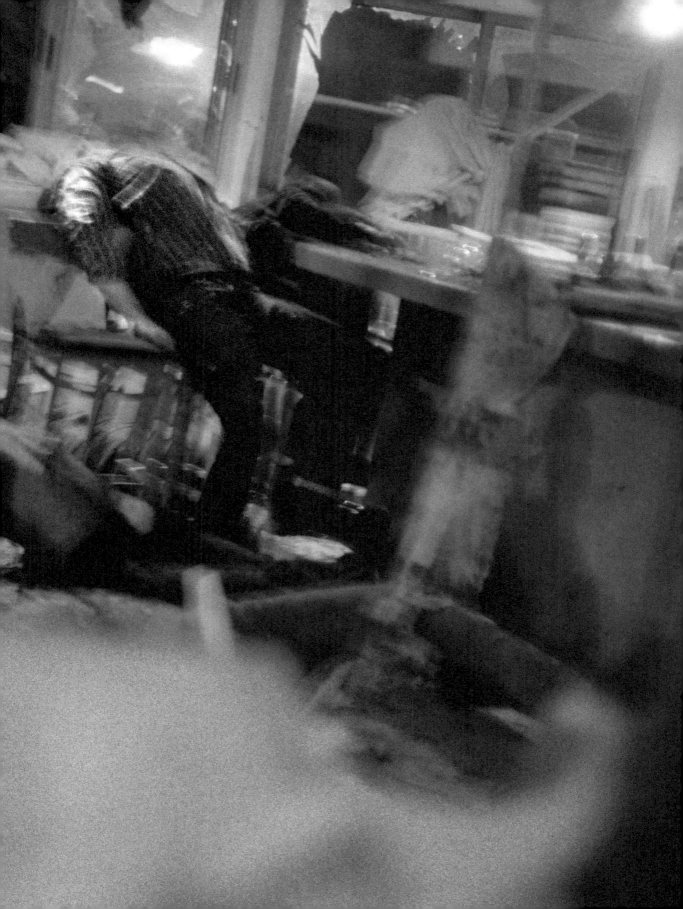

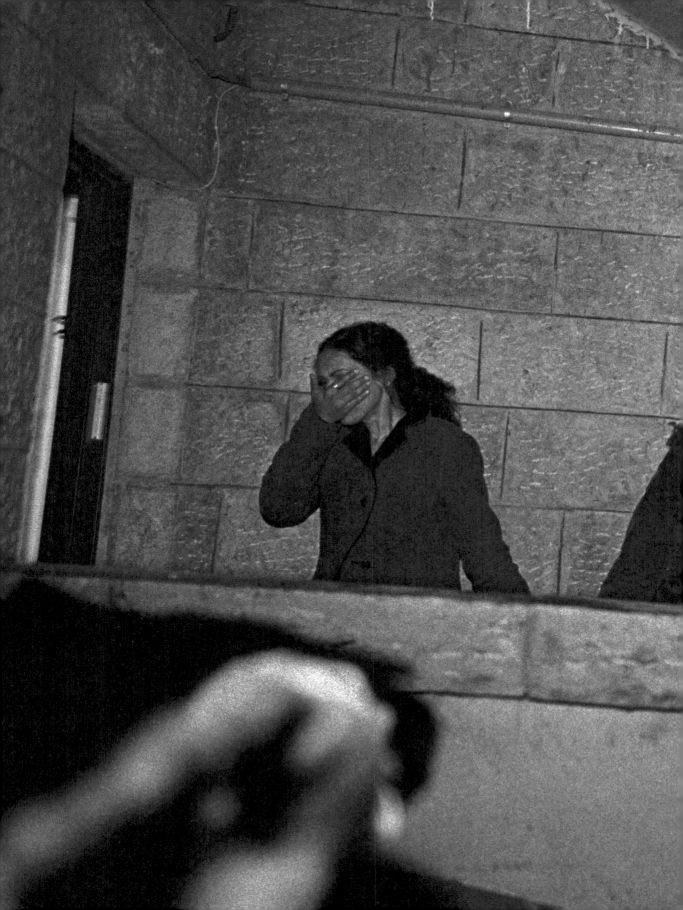

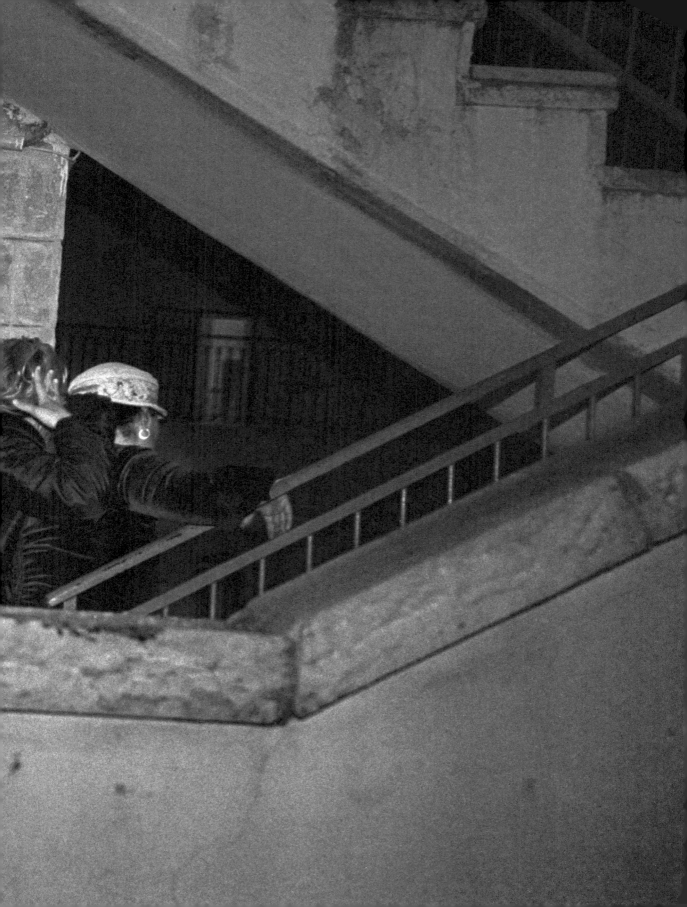

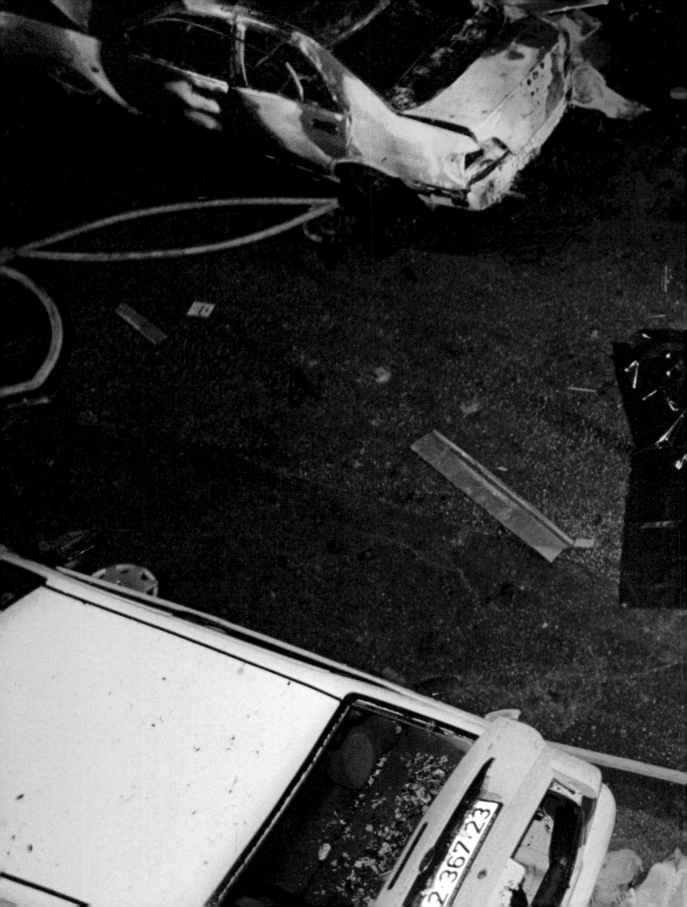

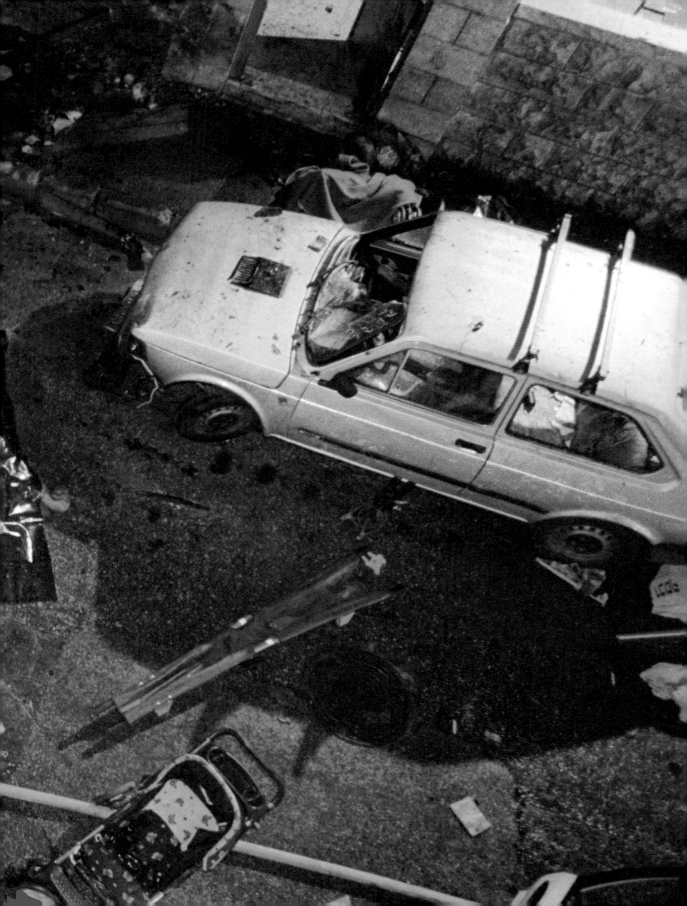

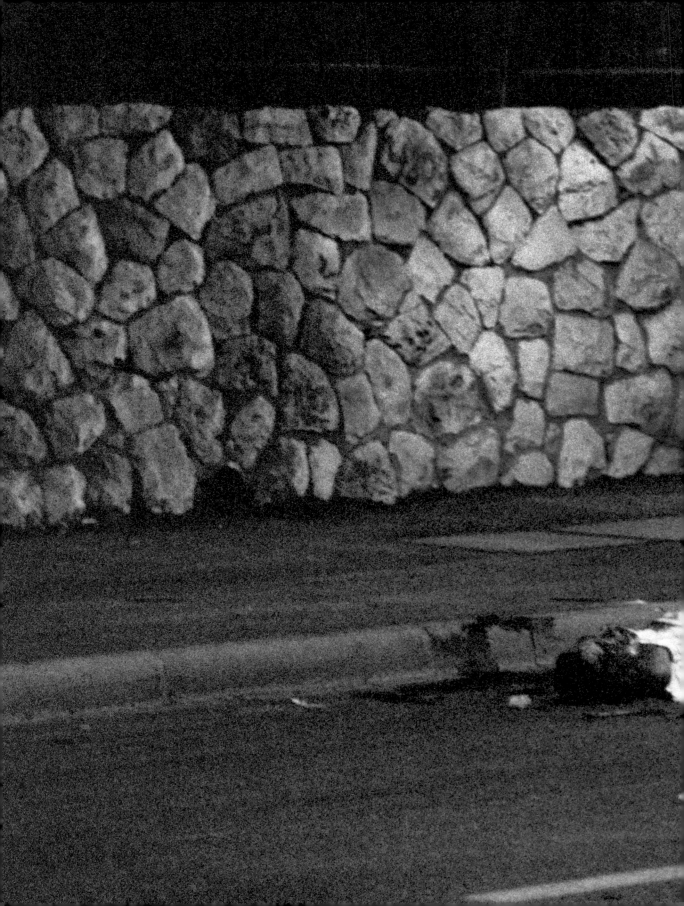

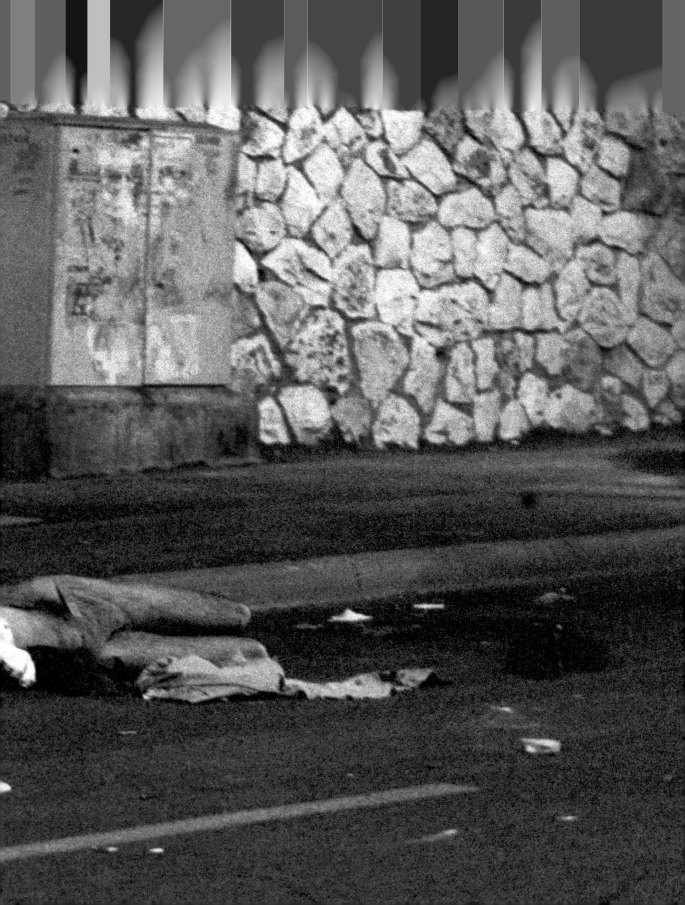

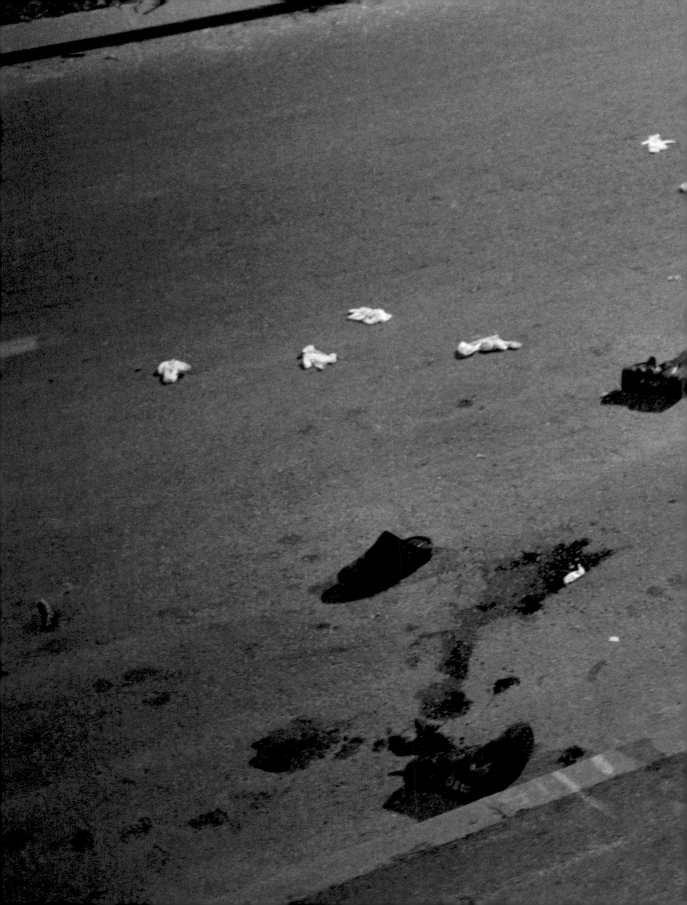

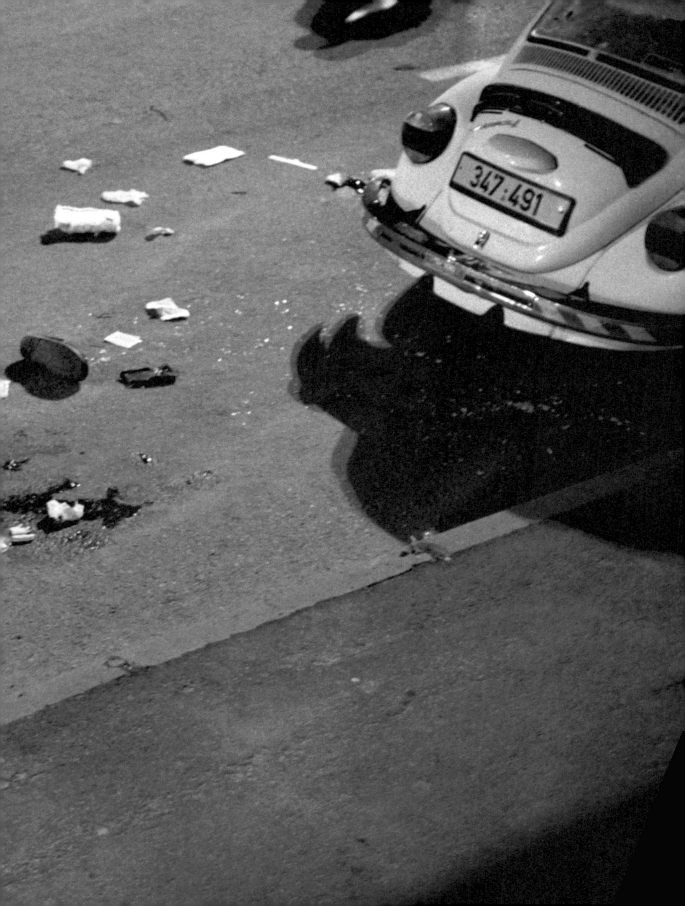

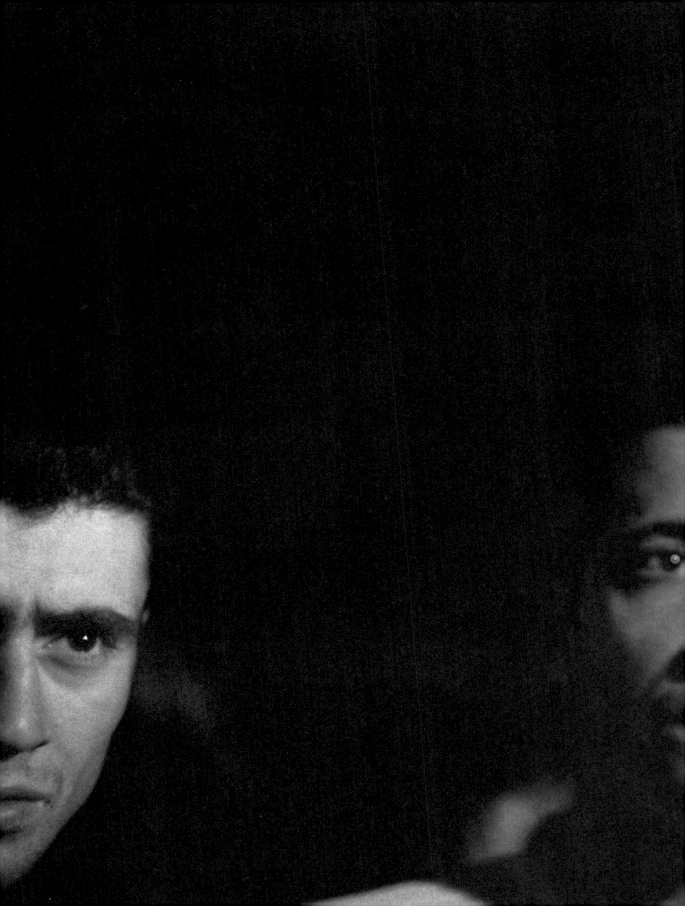

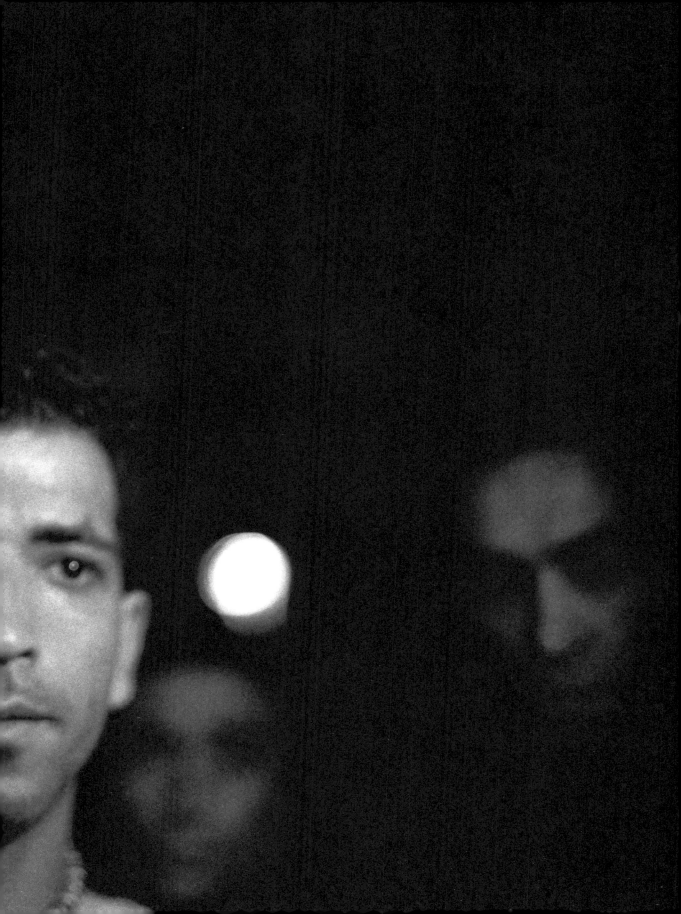

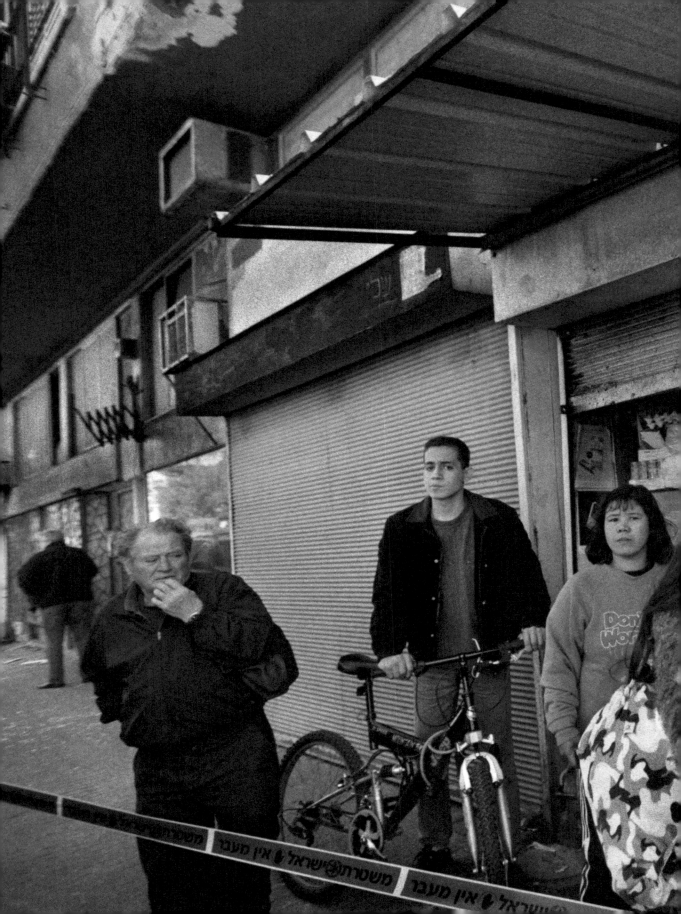

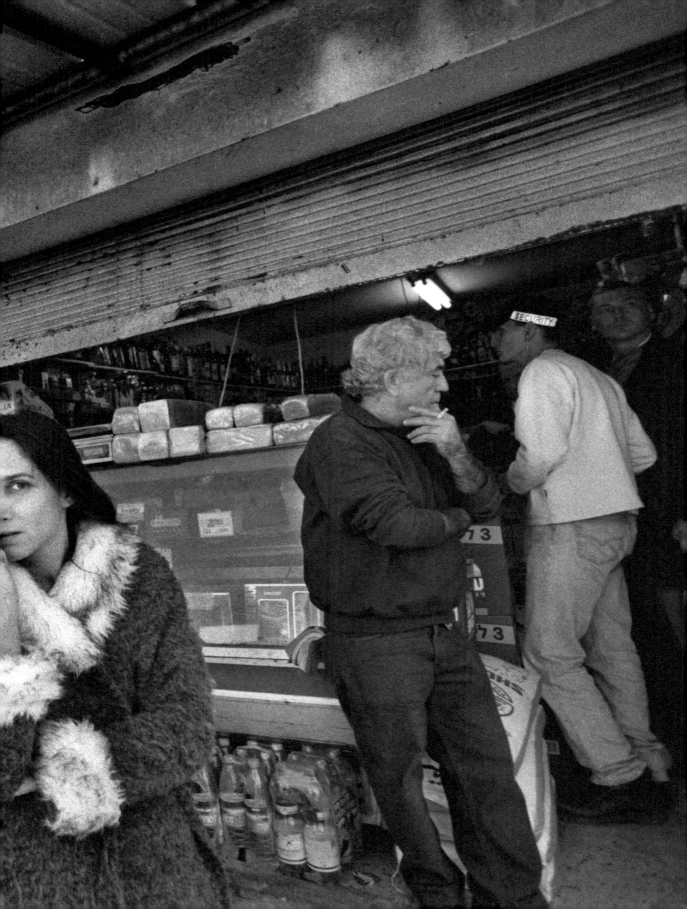

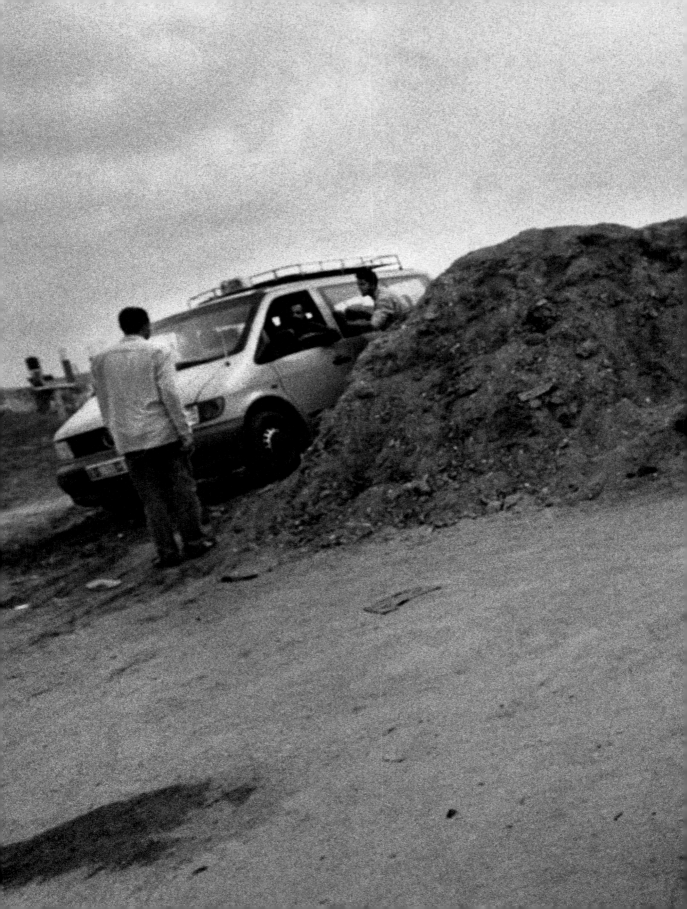

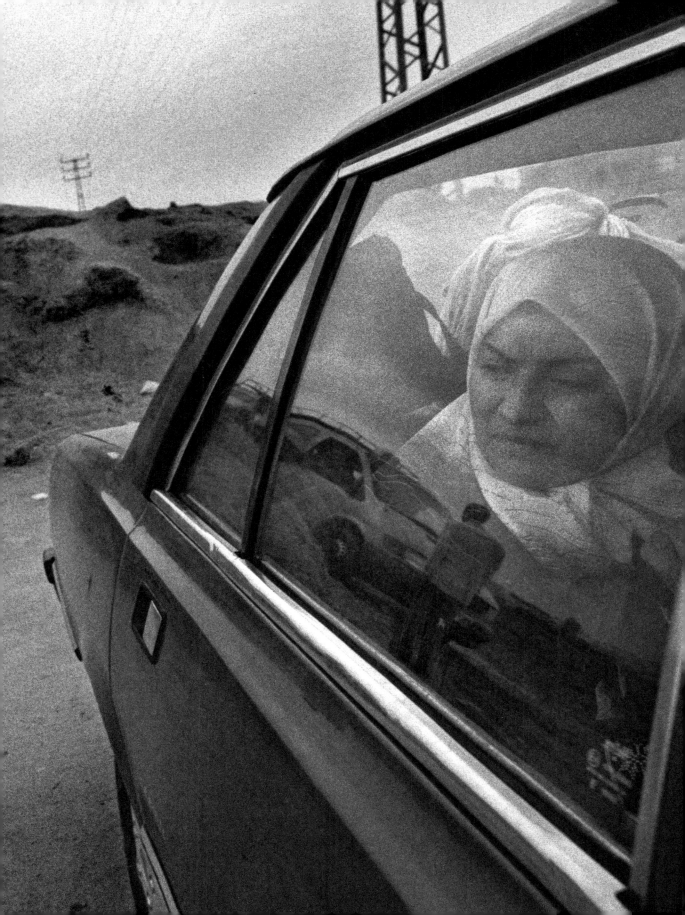

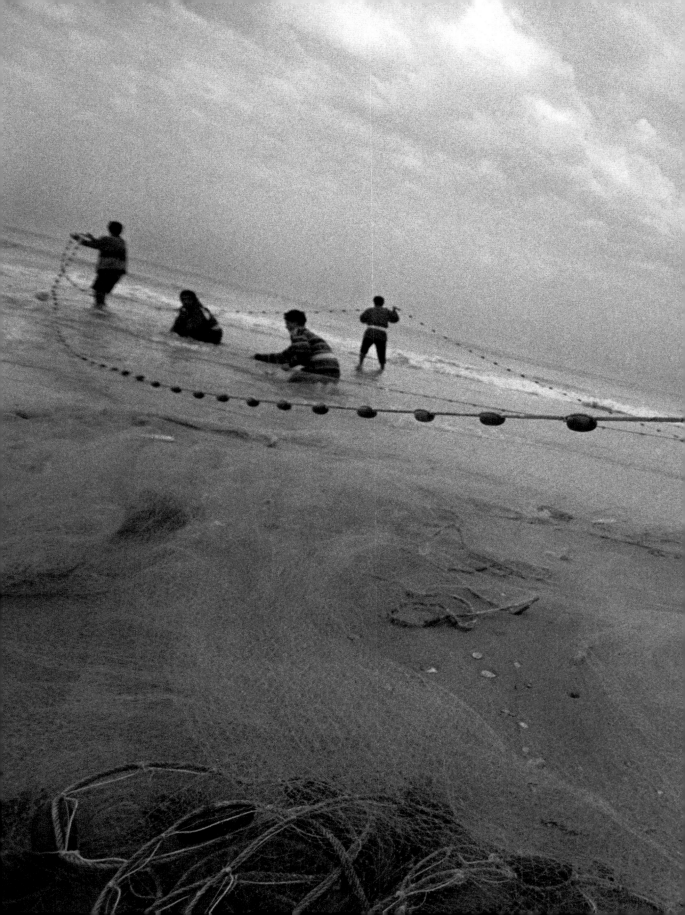

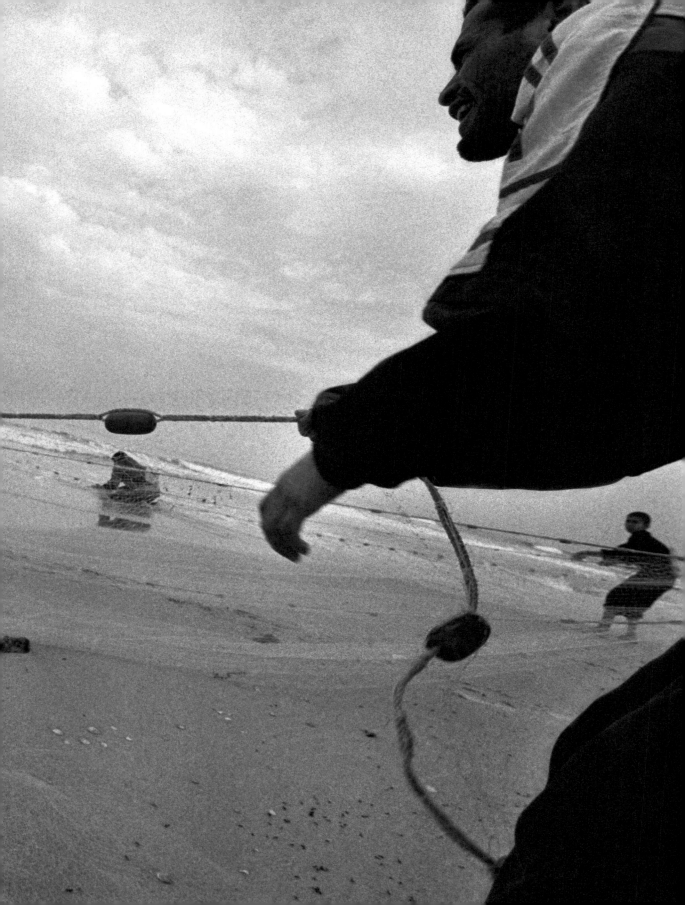

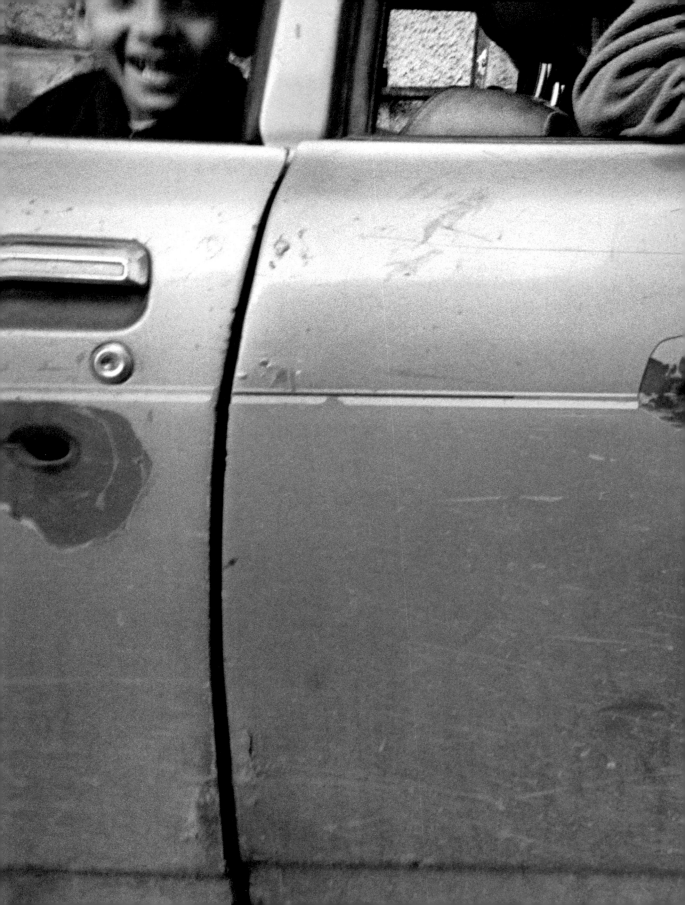

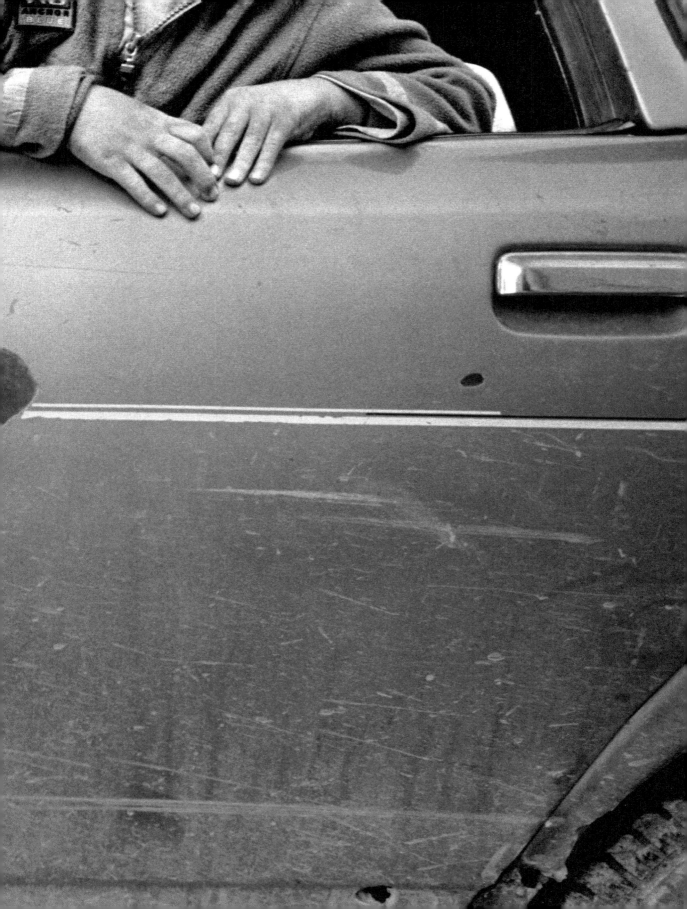

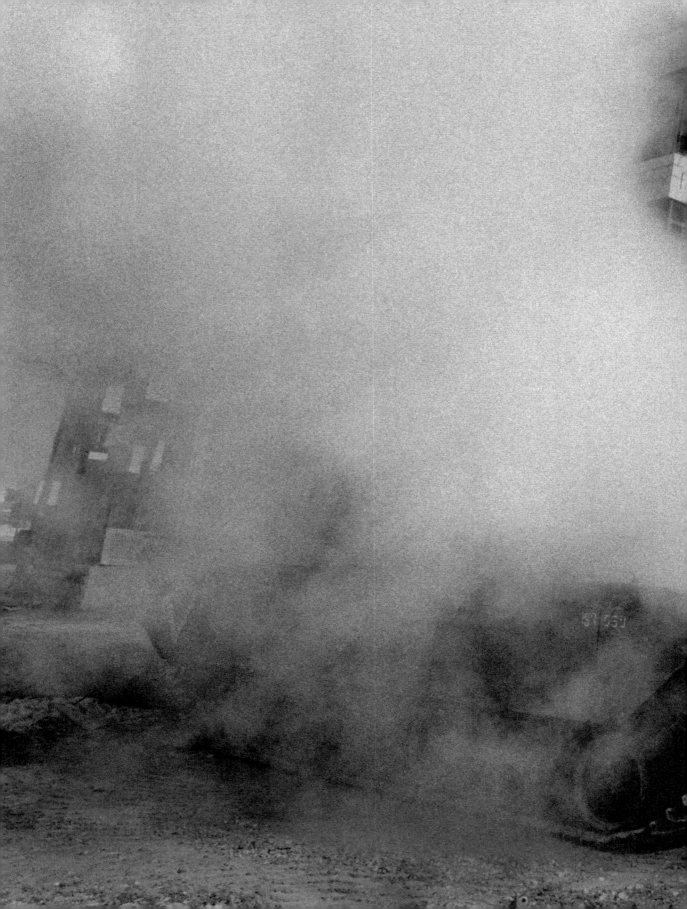

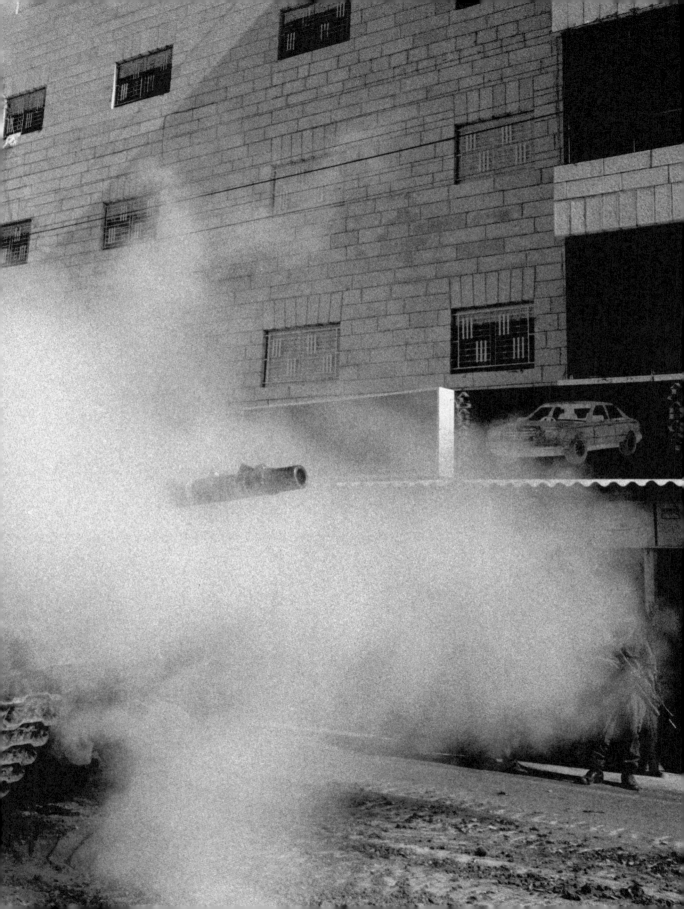

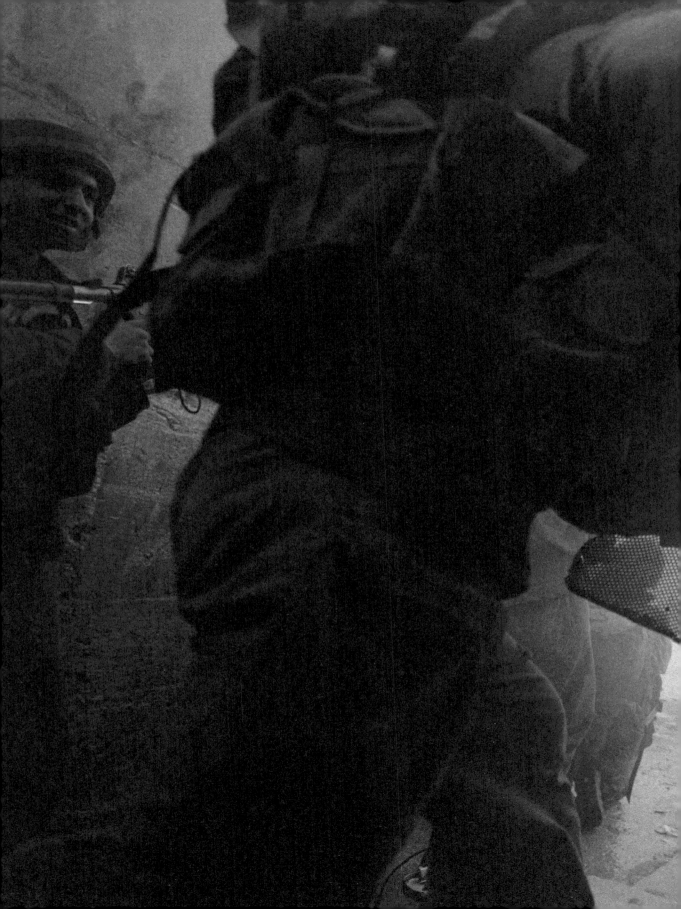

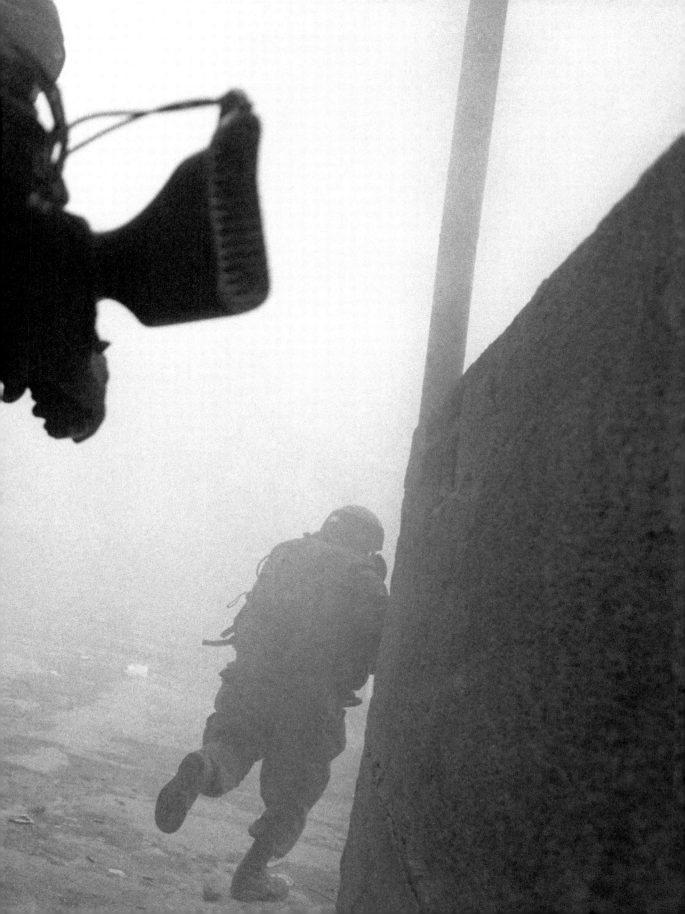

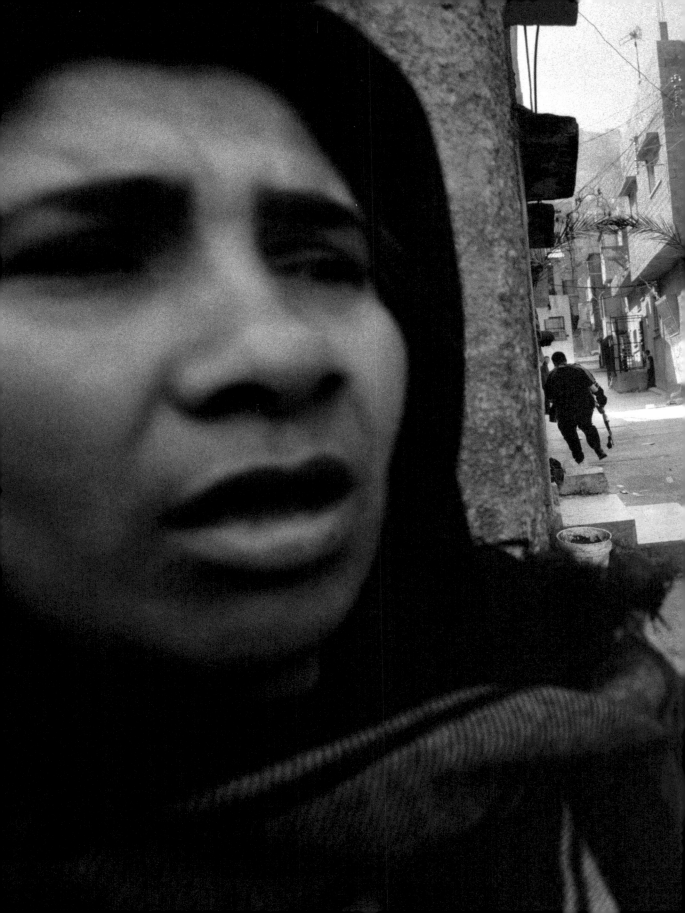

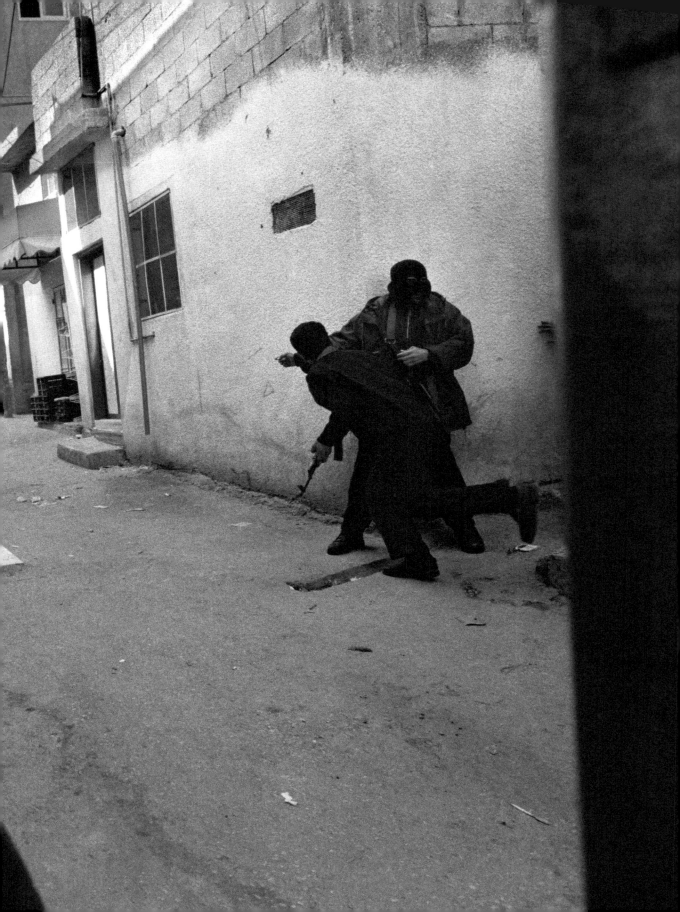

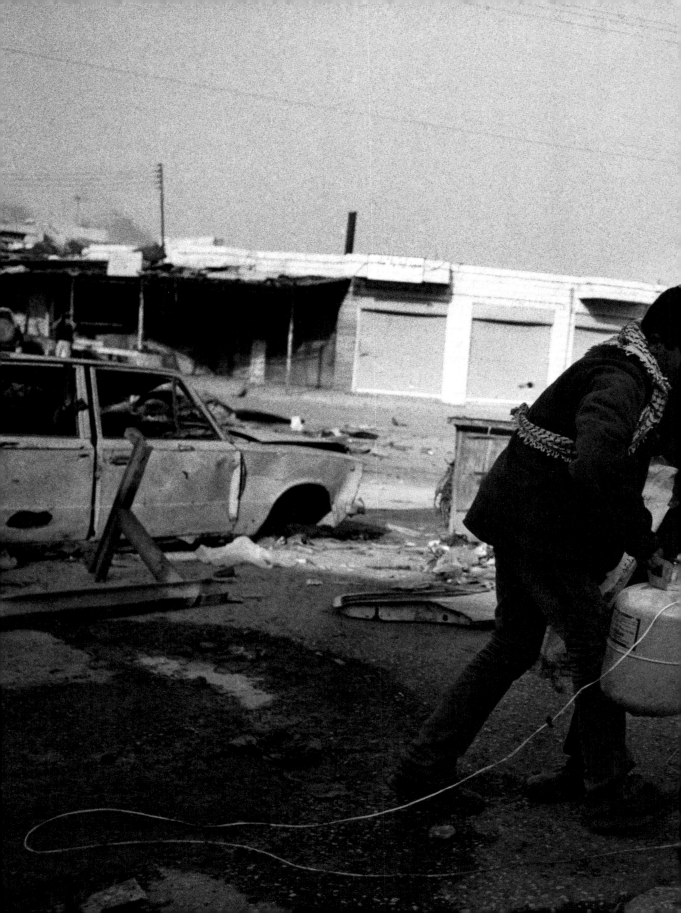

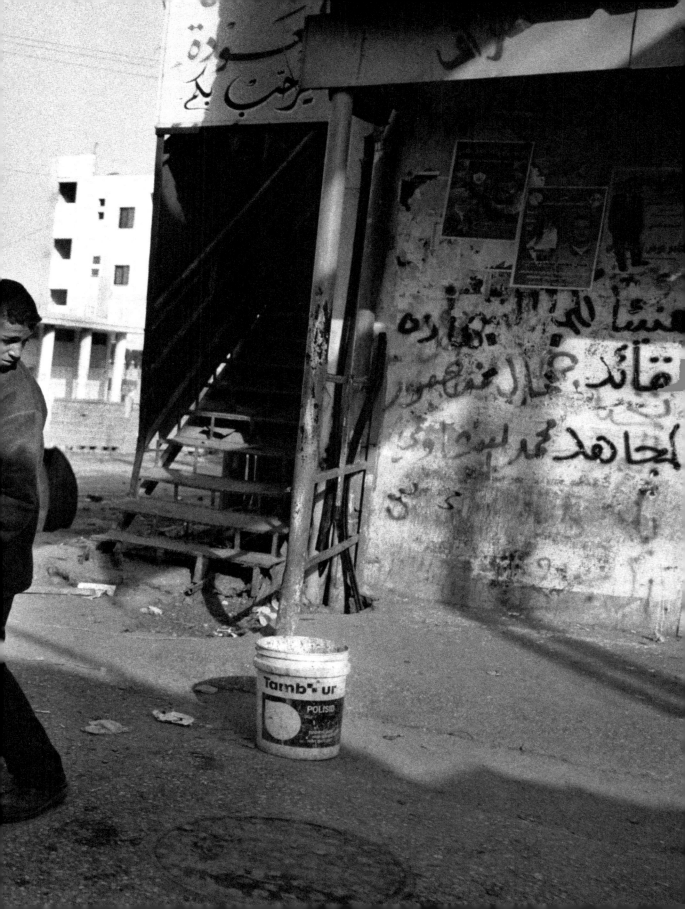

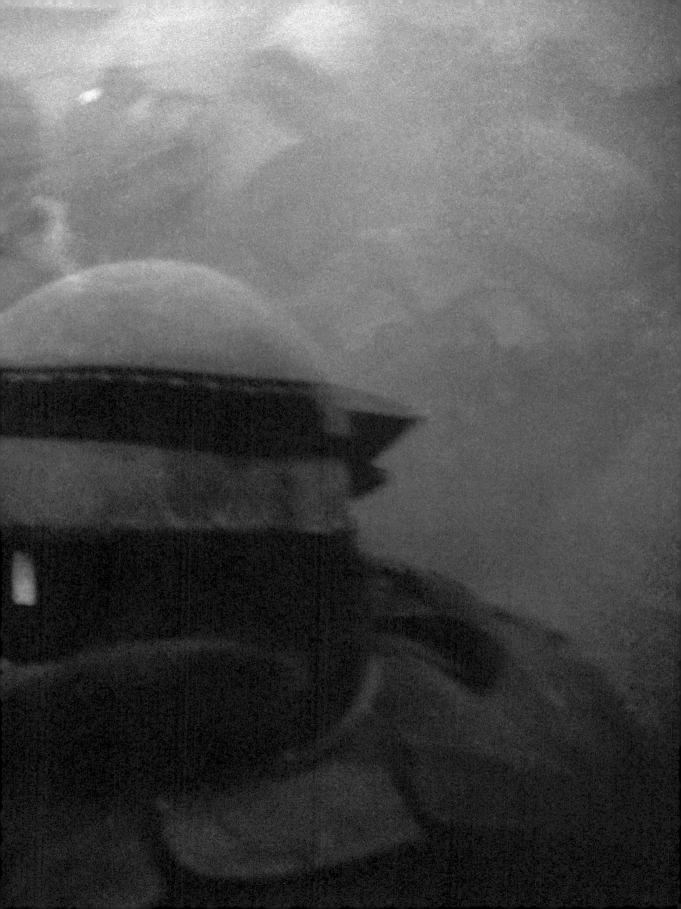

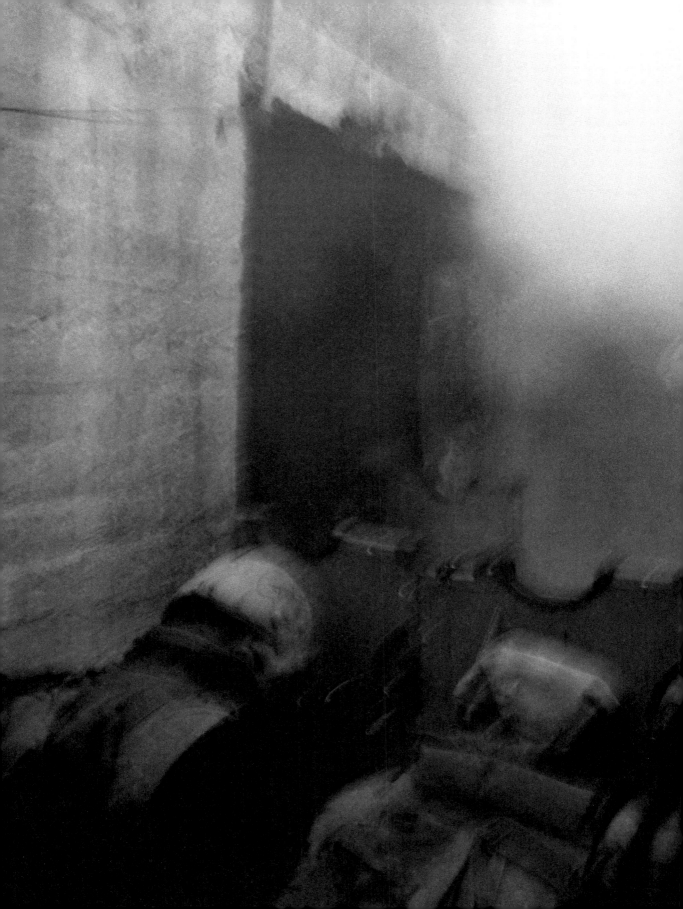

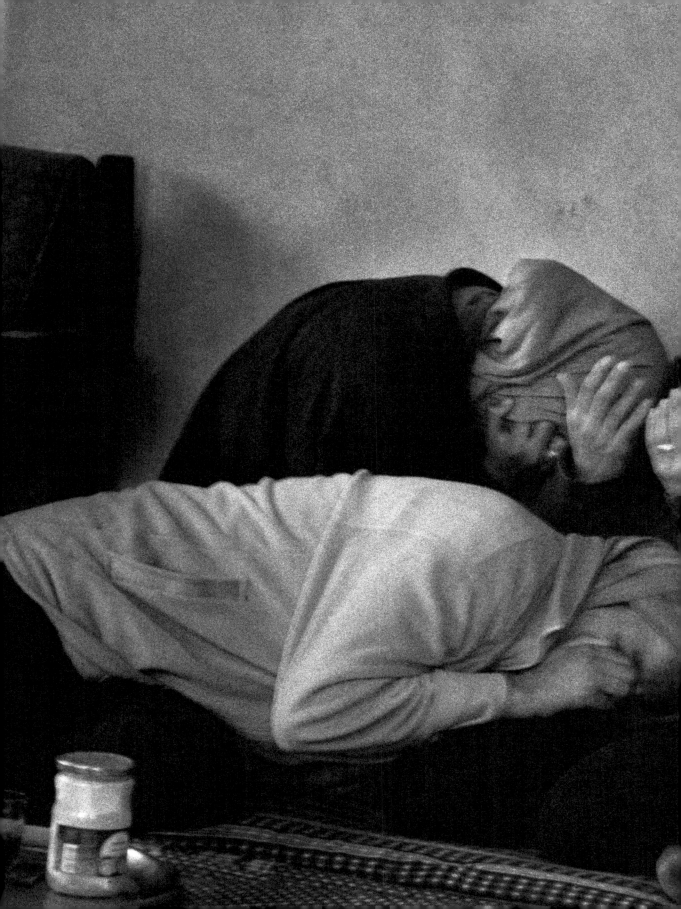

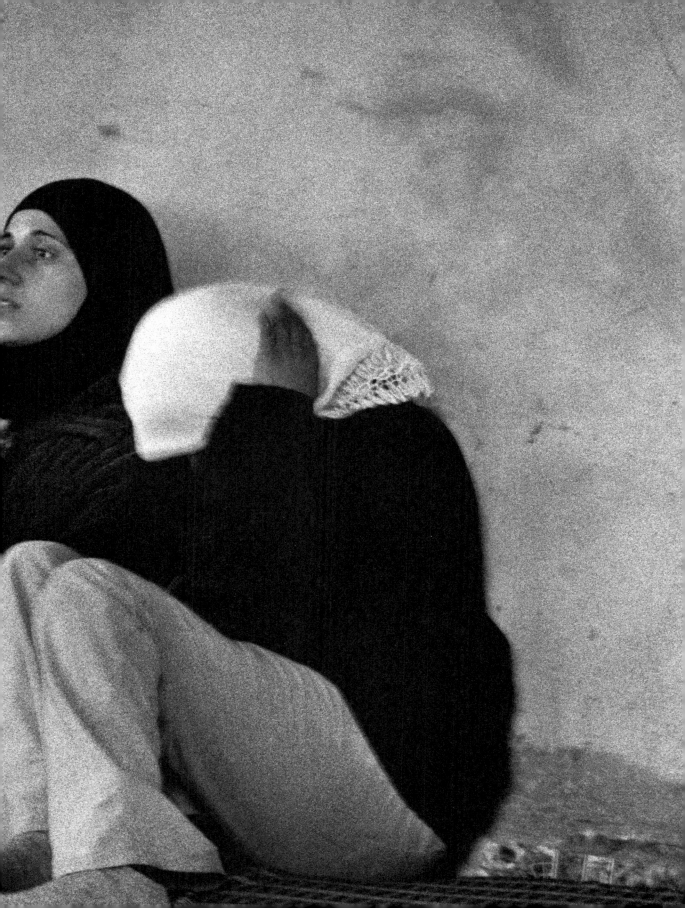

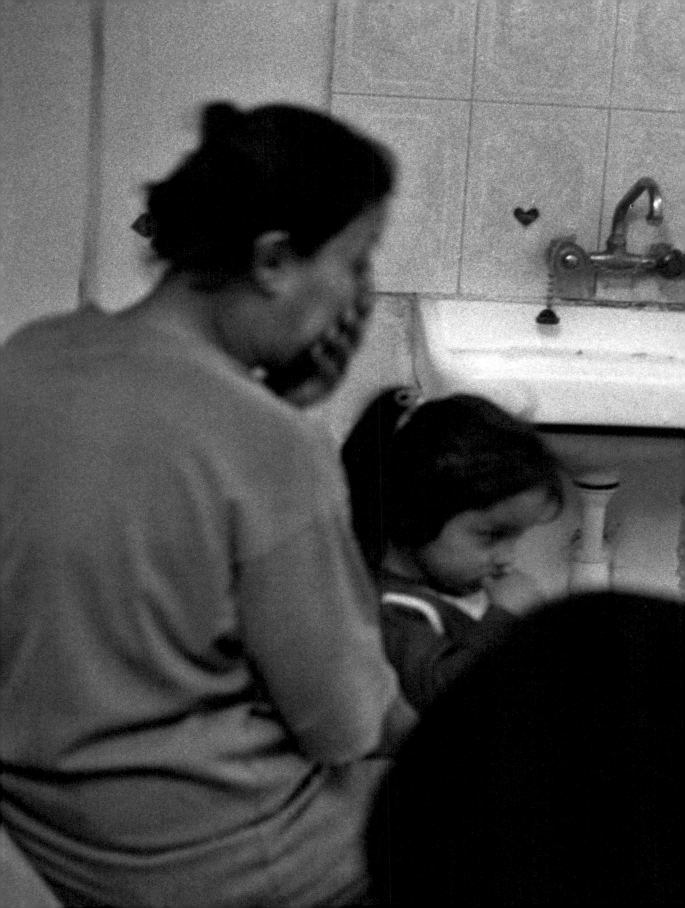

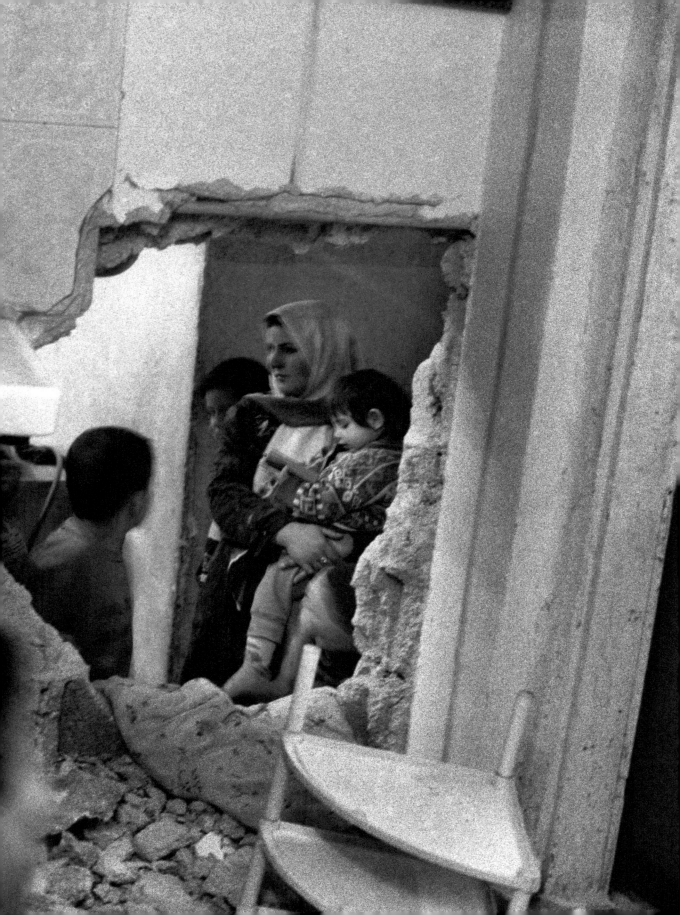

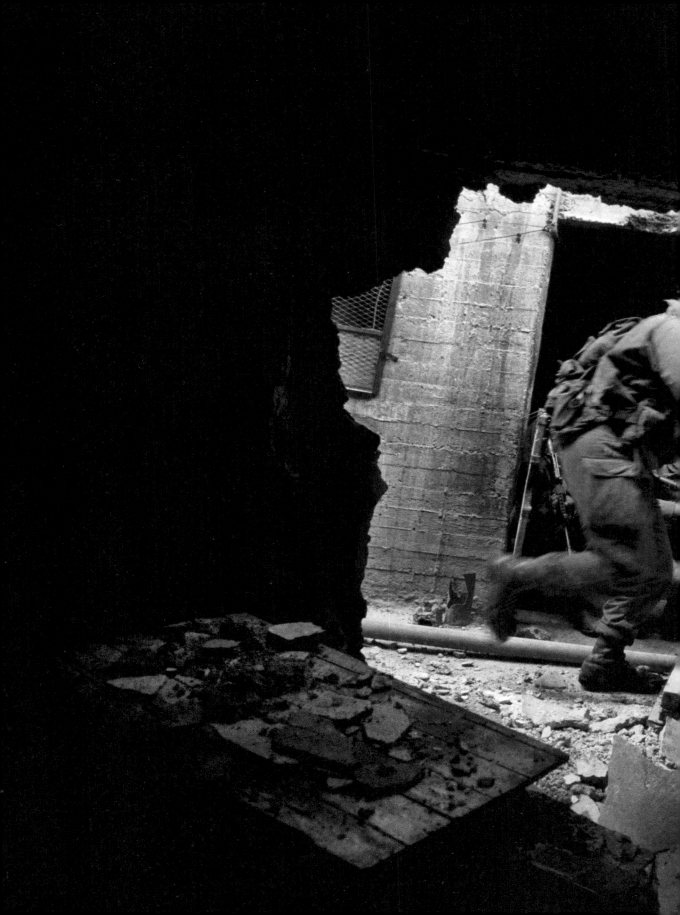

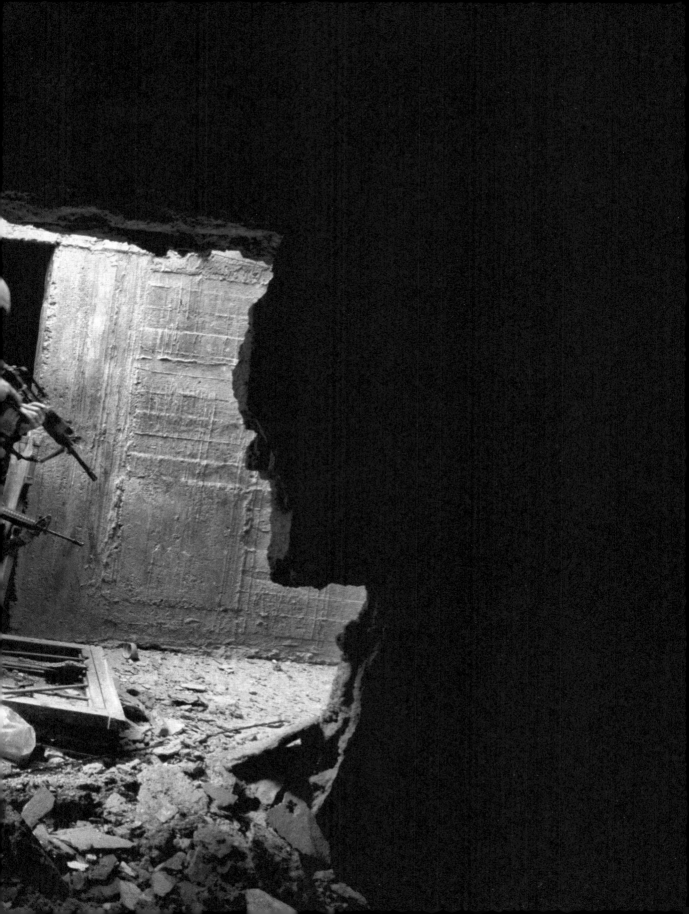

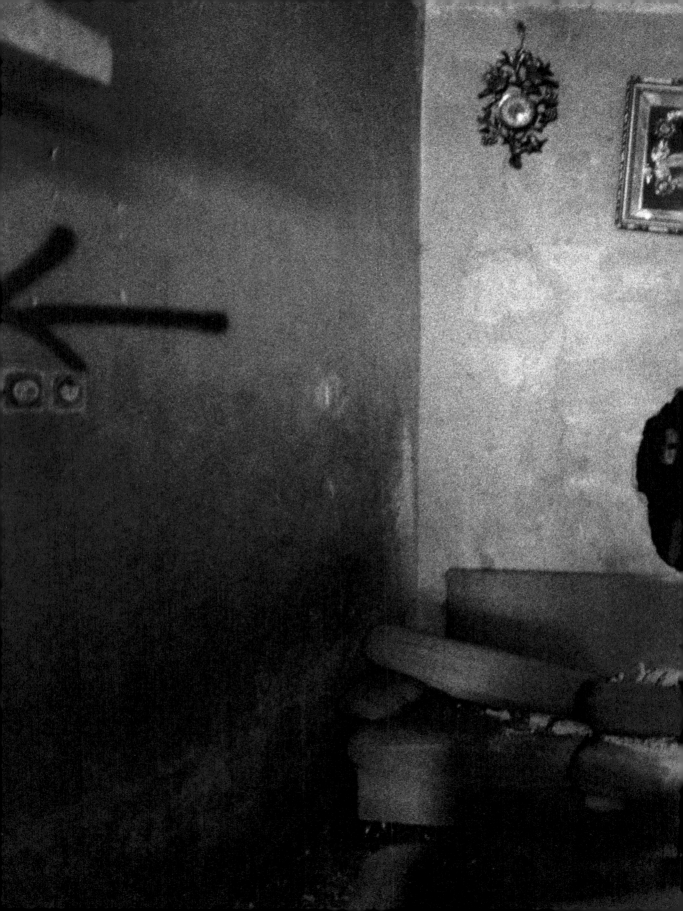

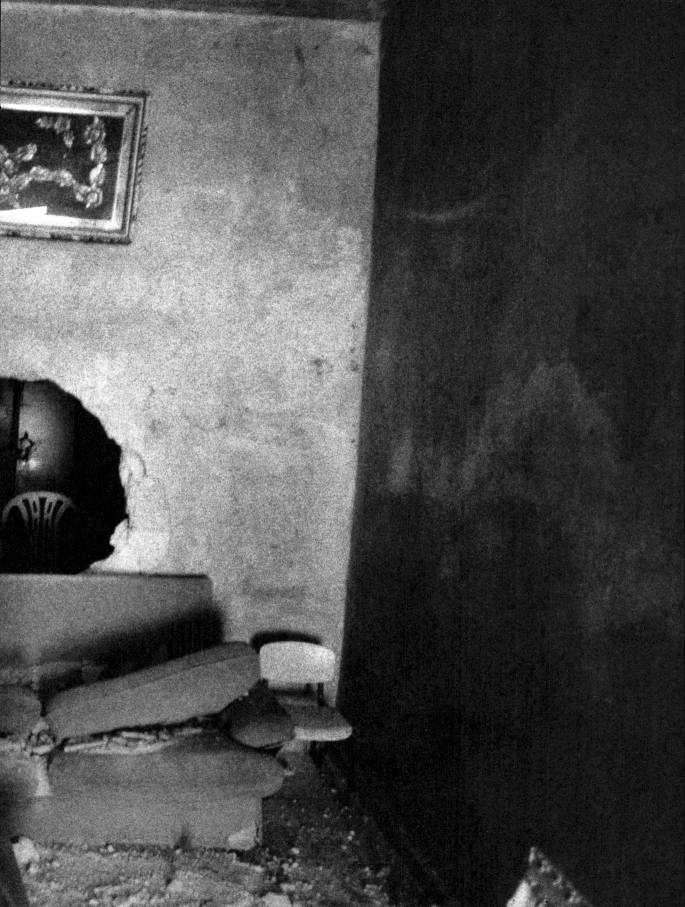

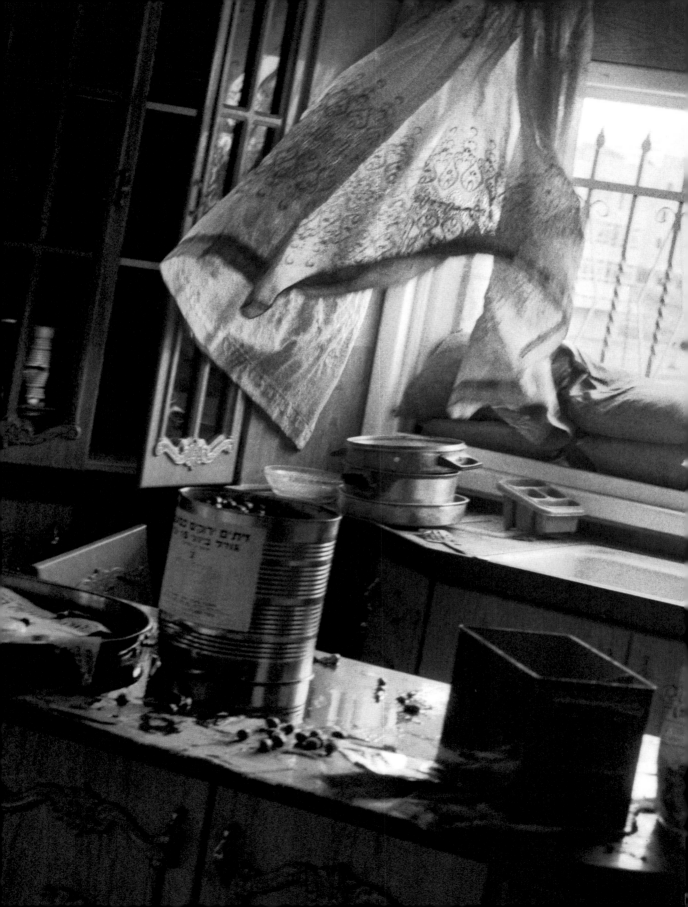

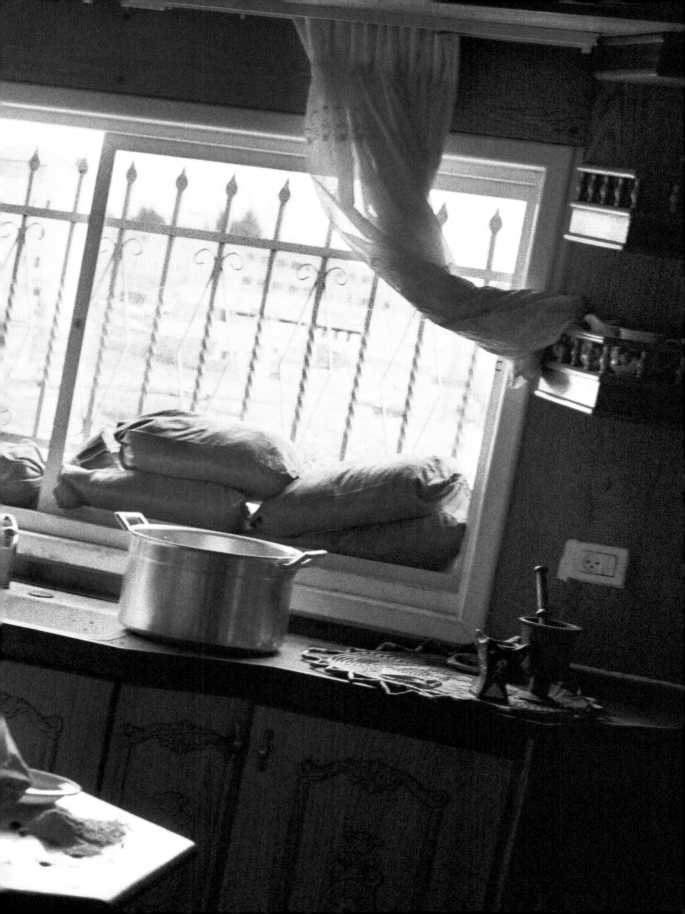

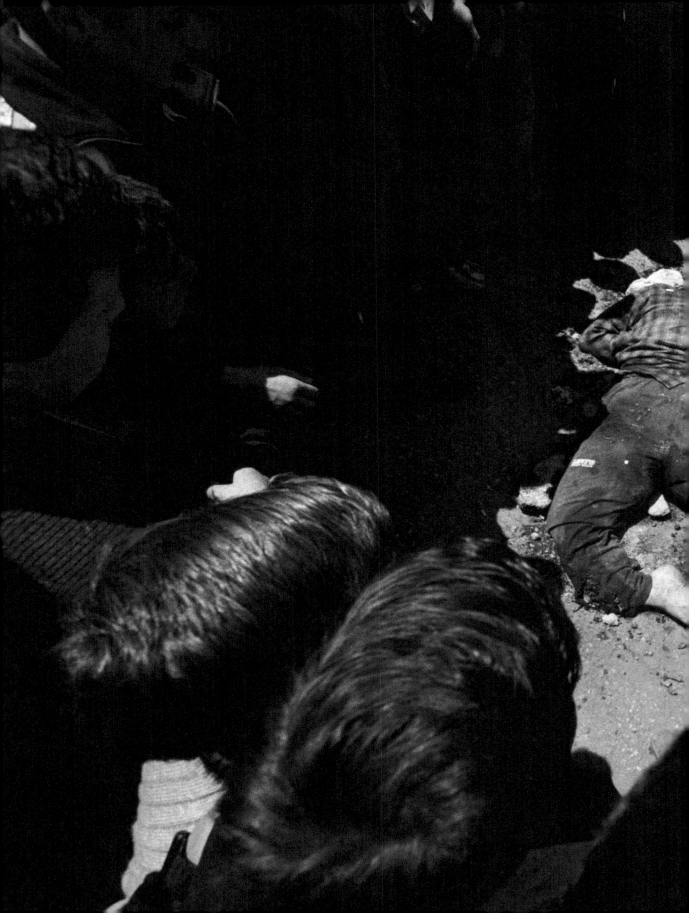

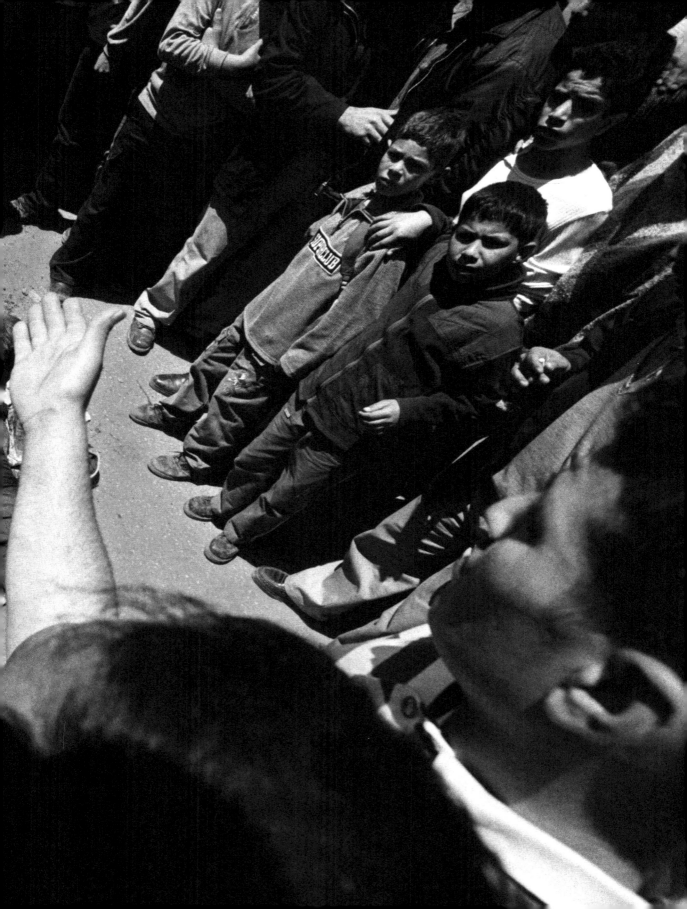

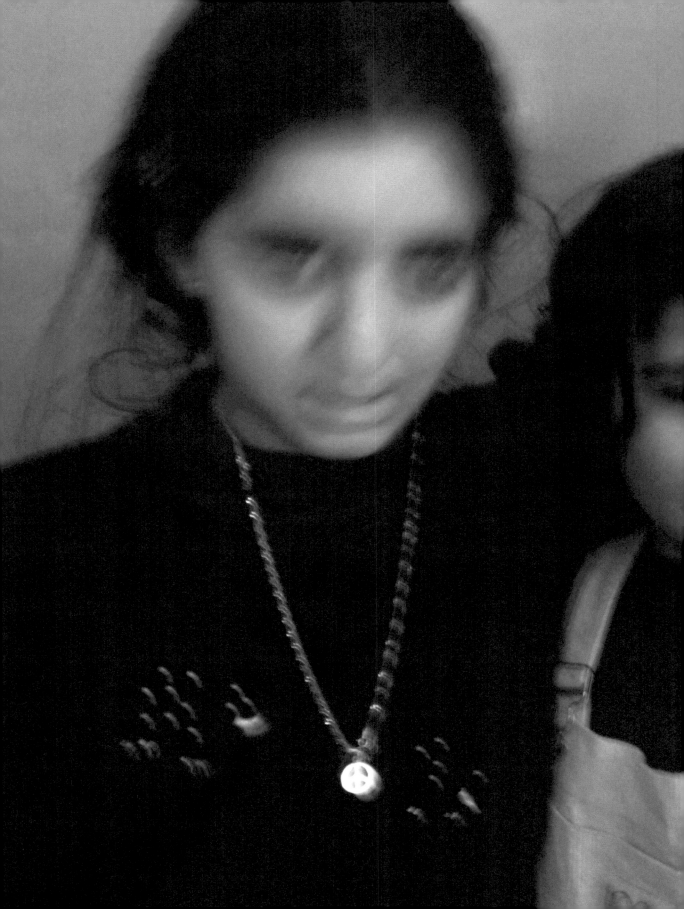

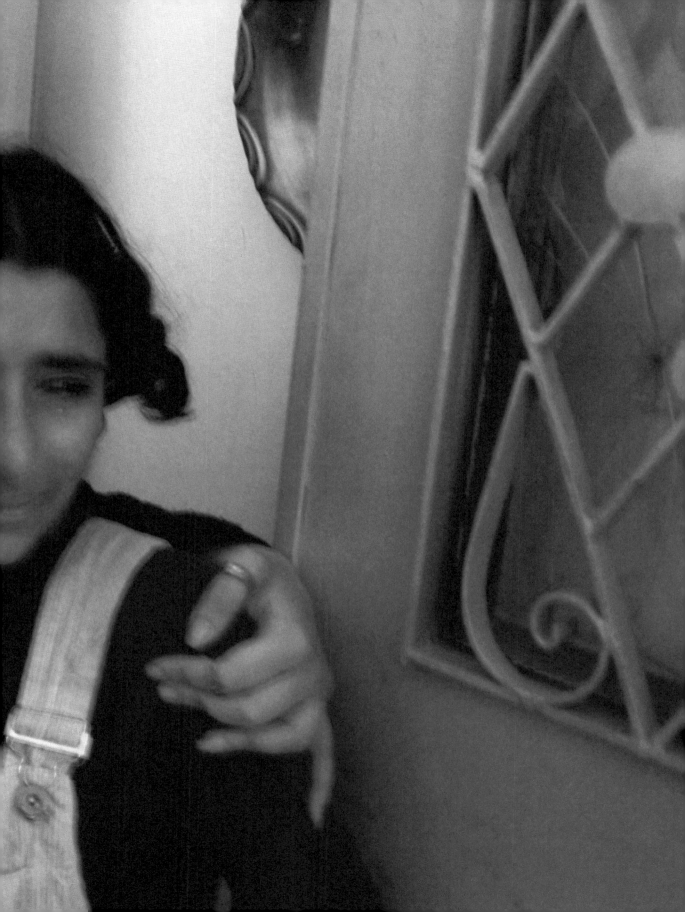

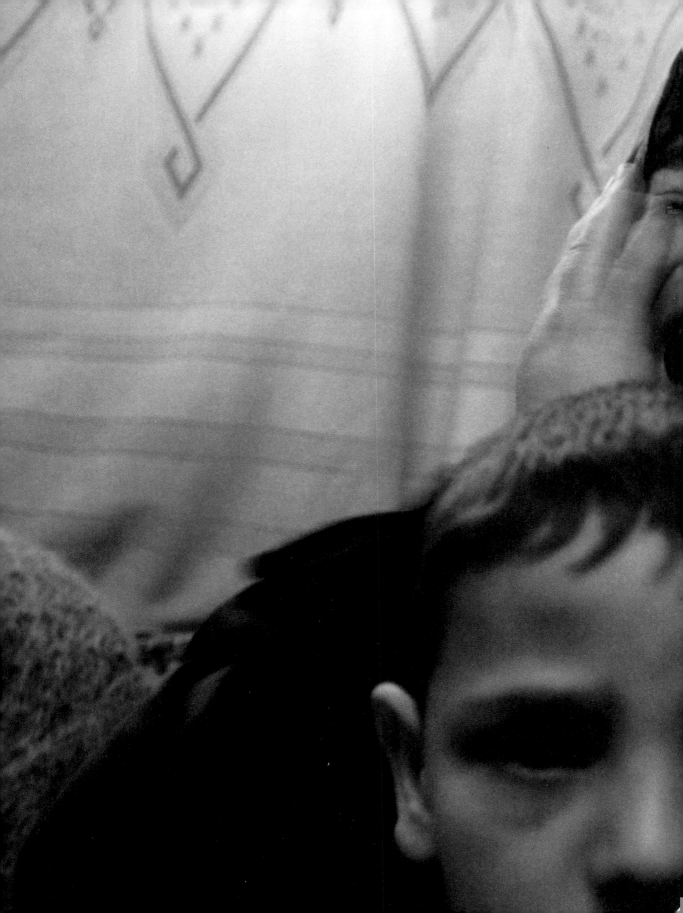

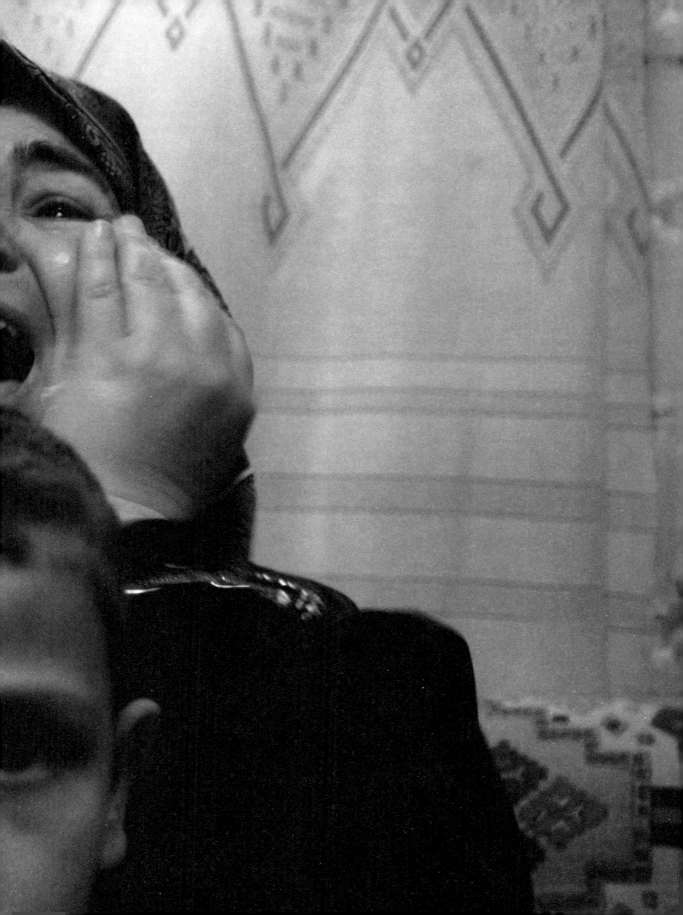

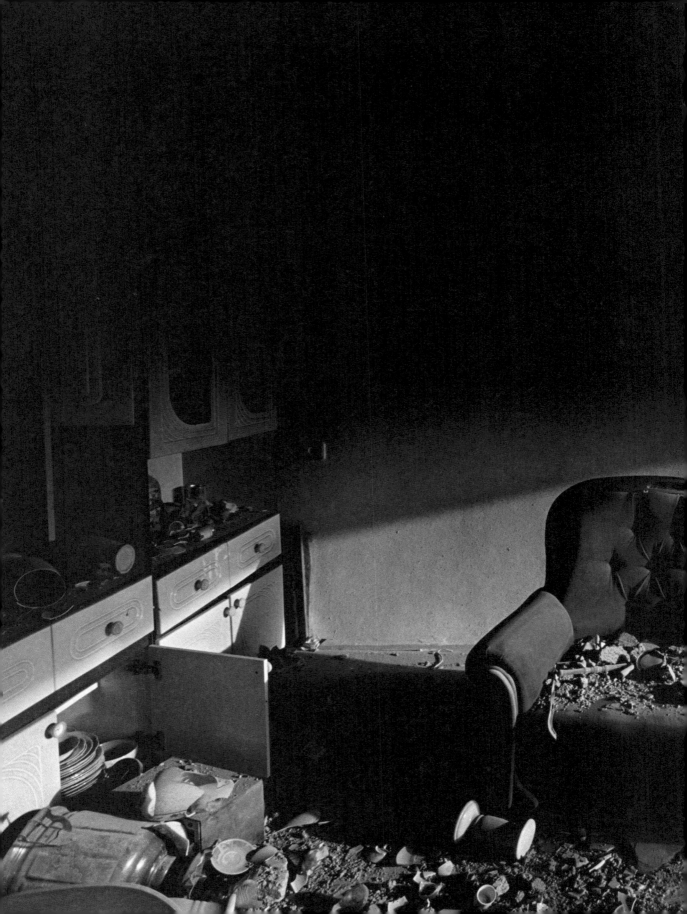

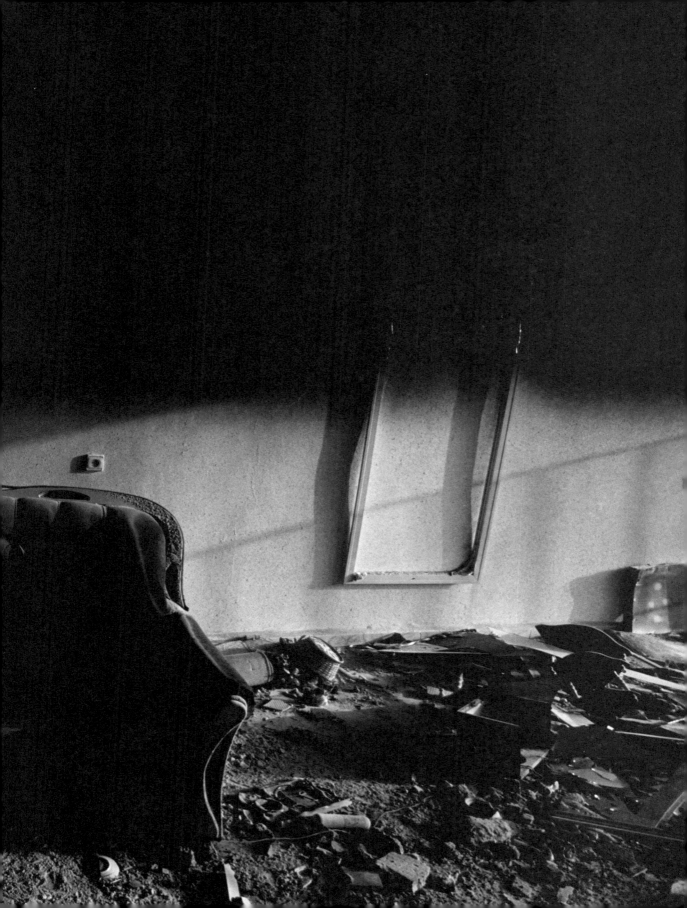

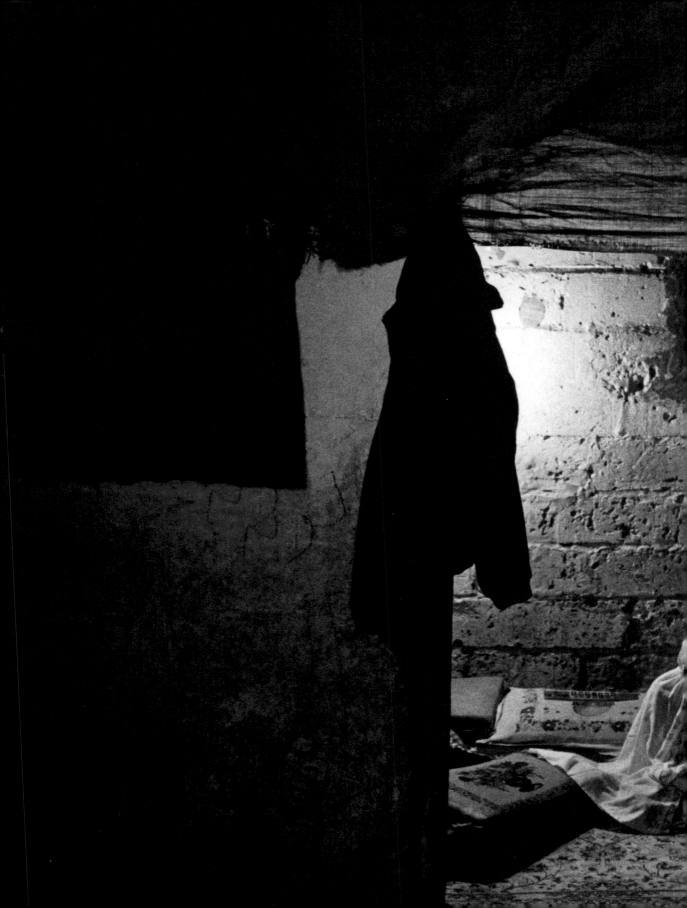

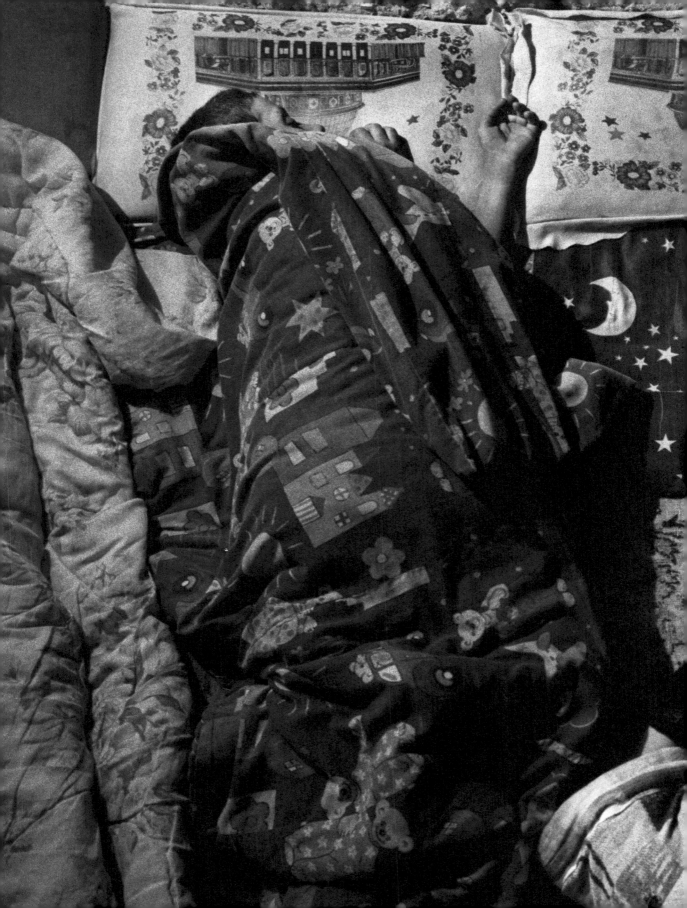

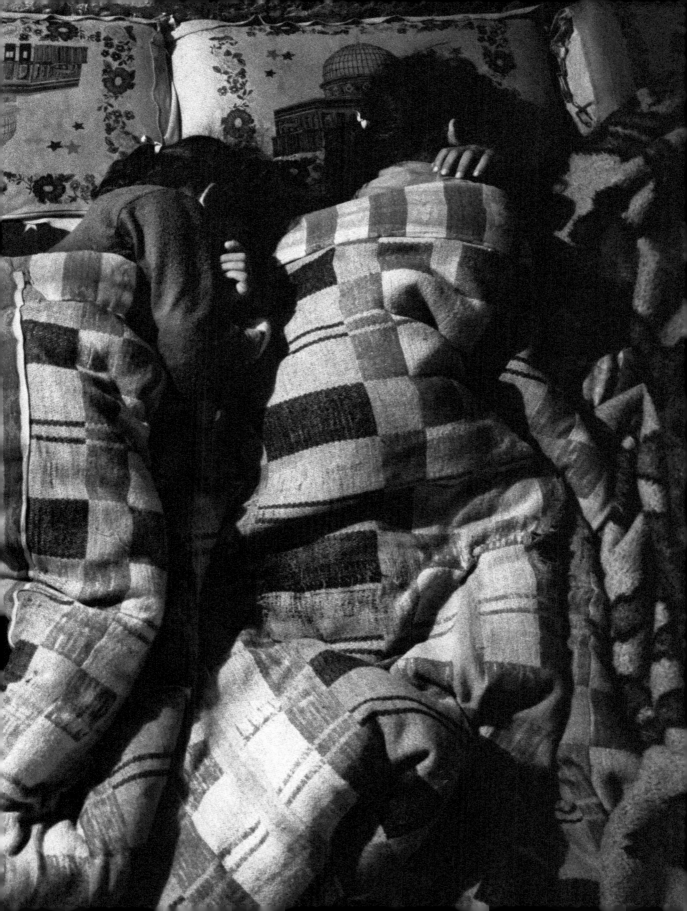

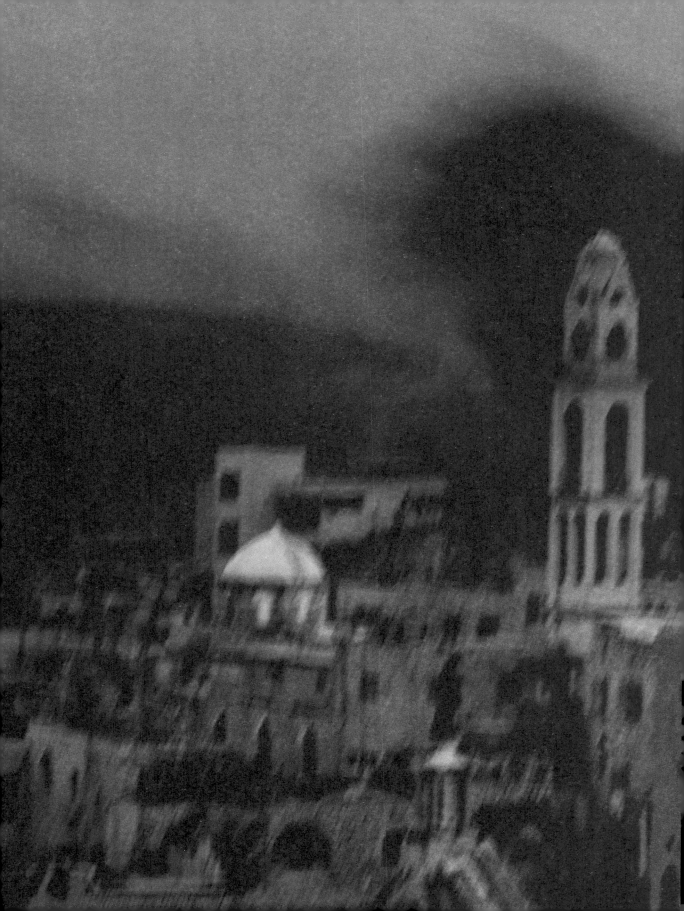

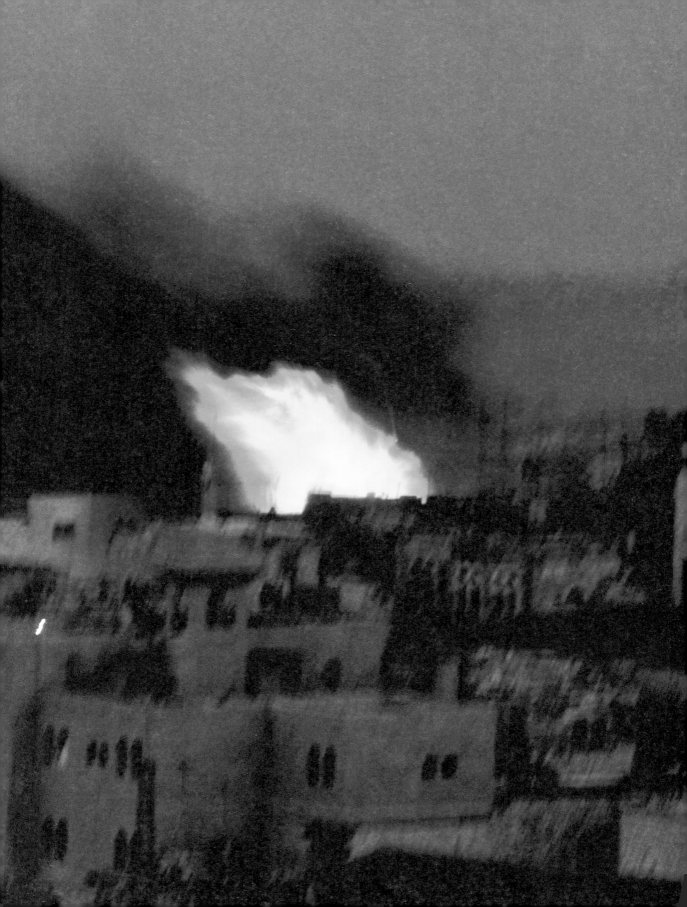

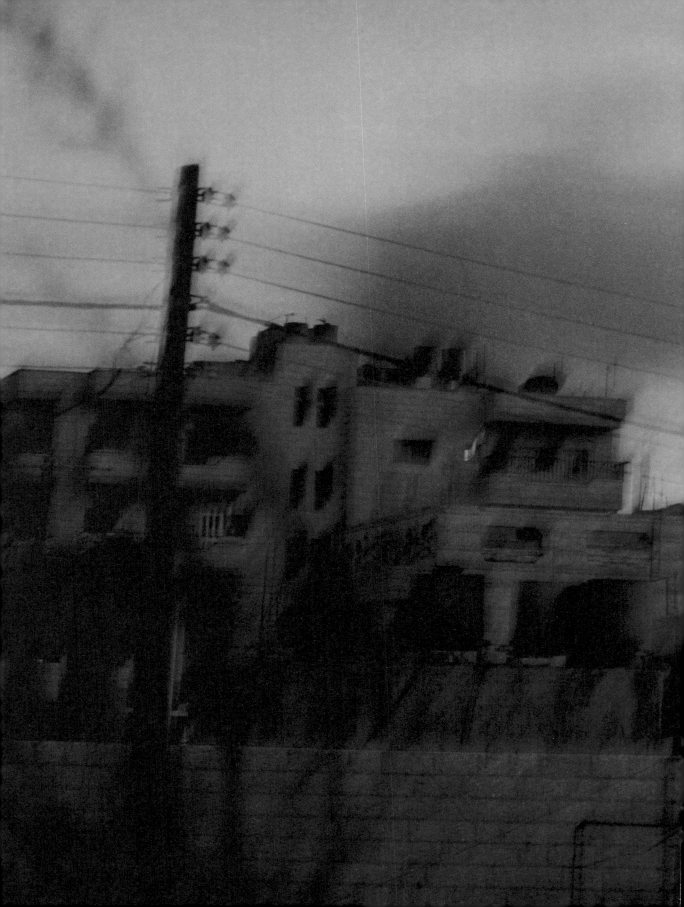

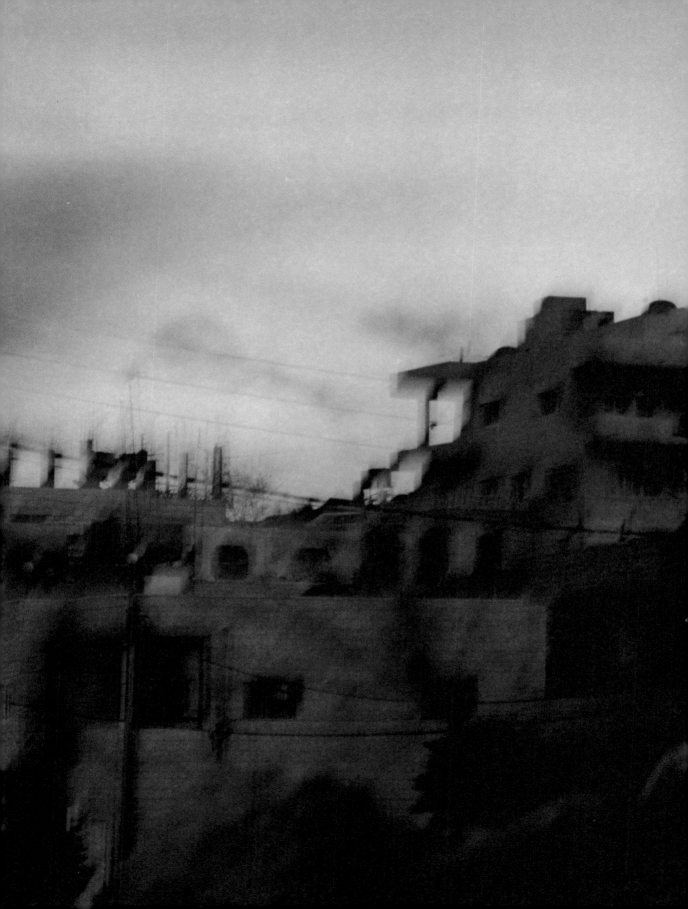

All the photographs in CYCLES
were taken between September
2000 and December 2002.

Rational argument can be conducted
with some prospect of success only
so long as the emotionality of a
given situation does not exceed a
certain critical degree. If the
affective temperature rises above
this level, the possibility of reason's
having any effect ceases and its place
is taken by slogans and chimerical
wish fantasies.

C.G. Jung
Civilization in Transition
Present and future
1957

Jerusalem

Jerusalem

Jerusalem

Jerusalem

Jerusalem

Jerusalem

Jerusalem

Ramallah

Ramallah

Ramallah

Jerusalem

Jerusalem

Jerusalem

Ramallah

Ramallah

Ramallah

Bethlehem

Ramallah

Nablus

Khan Yunnis

Tel Aviv

Jerusalem

Hebron

West Bank

Between Jerusalem
and Bethlehem

Jerusalem

Jerusalem

Jerusalem

Jerusalem

Jerusalem

East Jerusalem

East Jerusalem

East Jerusalem

Tel Aviv

Gaza City

Gaza City

Ramallah

Ramallah

Nablus

Nablus

Nablus

Nablus

Nablus

Nablus

Nablus

Nablus

Jenin

Nablus

Ramallah

Bethlehem

Nablus

Hebron

Jenin

Bethlehem

Jenin

Gaza City

Gaza City

Gaza City

Bethlehem

Bethlehem

Every word has been written
in a different light.

Published in Great Britain in (2004)
by Trolley Ltd
Unit 5 Building 13, Long Street
London E2 8HN, uk
www.trolleynet.com

ISBN 1-904563-36-8

Design Ilkka Uimonen

Printed in Italy by Soso.

My most sincere thank you to all
who gave their help to make this
book possible. Special thank you
to Gilles Peress, Sarah Harbutt,
Luc Delahaye, Jaime Welford,
Heidi Levine and Lorenza Orlando.

To my Stella...

0411